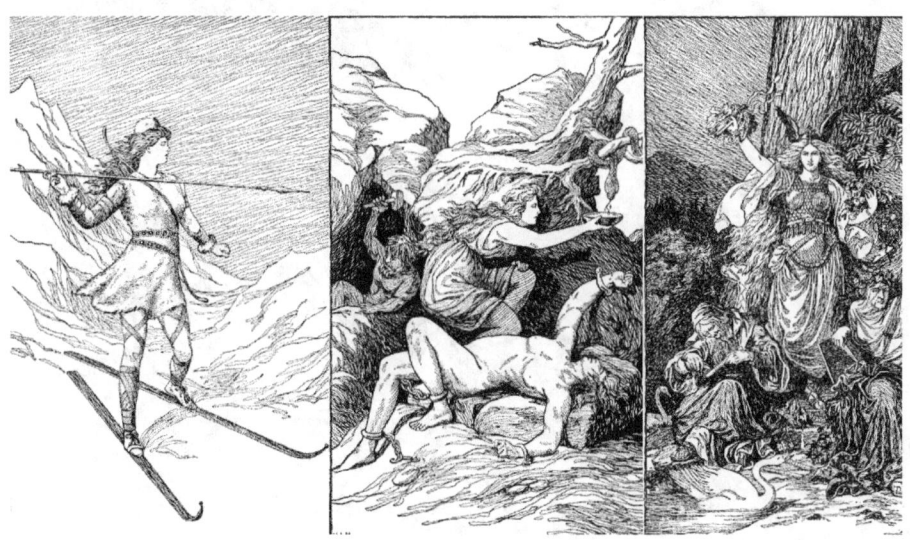

Norse Mythology

Edited by Lacey Belinda Smith

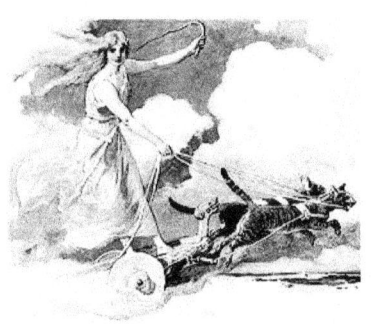
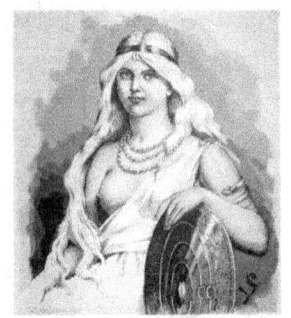

CONTENTS.

4	The Story of the Beginning
16	Valkyries
30	Odin's Reward
35	Tyr and the Wolf
40	Freyja's Necklace
49	*Skírnismál*
53	*Svipdagsmál*
57	The Hammer of Thor
66	Thor's Wonderful Journey
73	How Thor lost his Hammer
78	A Gift from Frigga
82	The Stealing of Iduna
92	Skaði
95	Baldur
101	Ægir's Feast
101	The Punishment of Loki
105	ÆGIR'S FEAST
111	The Twilight of the Gods
117	Appendix
126	Index of Names

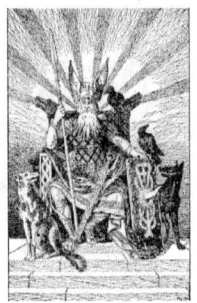

Odin--Allfather

The Story of the beginning

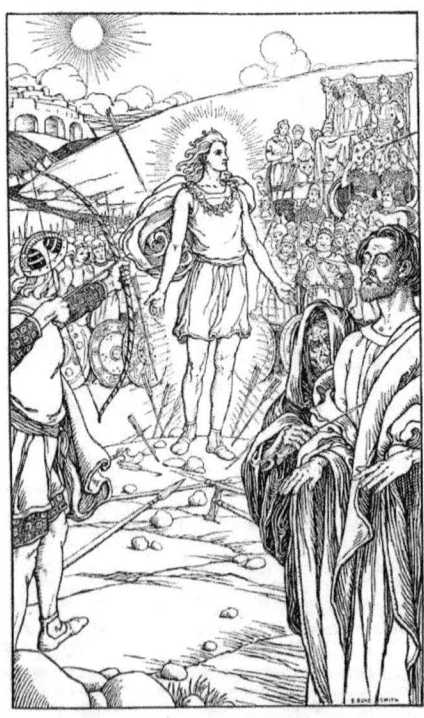

Baldur

In the beginning before living creatures were in the world, it was all rough and without order. Far to the north it was very cold. Toward the south there was fire, and from the meeting of the fire and the cold a thick vapor was formed, from which sprang a huge giant-- Ymir. On looking about for some food, he saw a cow, who was also searching for something to eat. The ice tasted

salty, and when the cow began to lick it, a head appeared, and at last the whole figure of a god stood before her.

From these two, the giant and the god, came the two great races of giants and gods, who were always enemies to each other. The giants were constantly trying to break into Asgard--home of the gods, in the sky. The gods watched and planned to keep out the giants and to drive them back to their own stronghold--Utgard. Our world, where men and women lived, was between Utgard and Asgard--Midgard. Under the ocean, was coiled a monstrous serpent--the Midgard serpent.

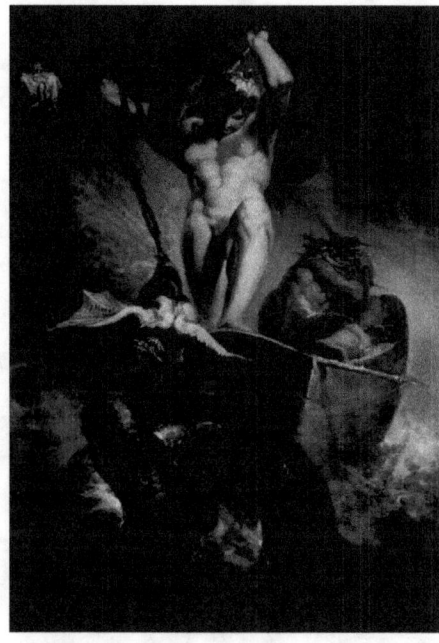

Thor Battering the Midgard Serpent-- Henry Fuseli--1790

A wonderful tree called Yggdrasil connected all the worlds. This great ash tree had its roots in Utgard and the tops of its branches reached up so that it overshadow Asgard. Its three main roots were watered by three fountains. Near one of them sat the wise giant Mimir, and three sisters-- Norns-- lived at the roots of Yggdrasil, and were careful to see that it was watered every day. The Norns ruled over the destiny of men and gods.

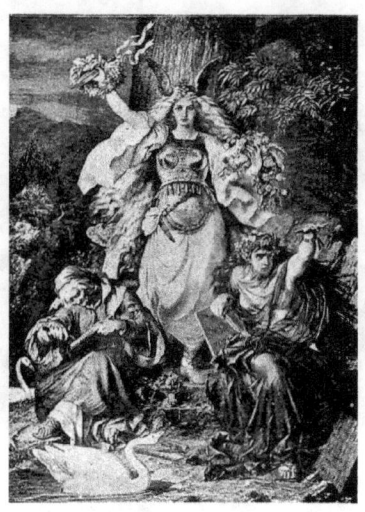

After the painting by Ehrenberg,
THE NORNS.

Mímir was the wisest of the gods of the tribe Aesir.

The gods and goddesses, all together, were called the Æsir. The chief and father of them all was Odin. His high throne rose up in the midst of the sacred city Asgard.

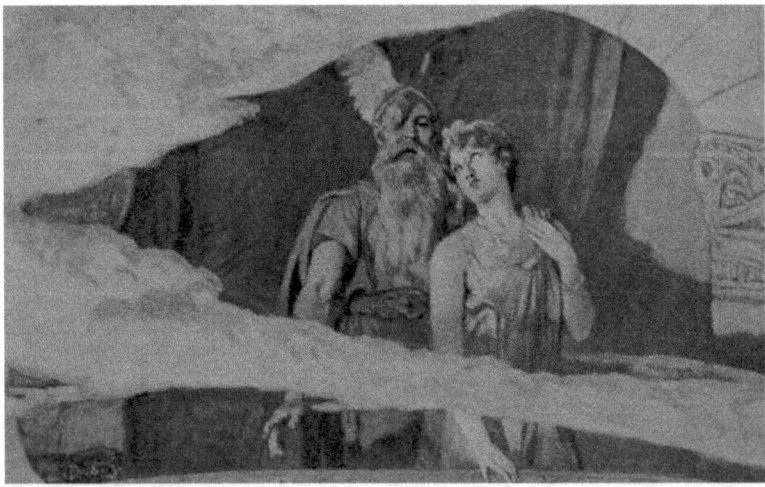

Odin and Frea look down from their window in the heavens to the Winnili women in an illustration by Emil Doepler, 1905.

From Asgard, arching over and down to the lower world, was a rainbow bridge, called Bifröst—"the trembling bridge"; upon this the dwellers in Asgard could travel everyday, all except the mighty Thor. His thunder chariot was too heavy for "the trembling bridge," so he had to go around a longer way.

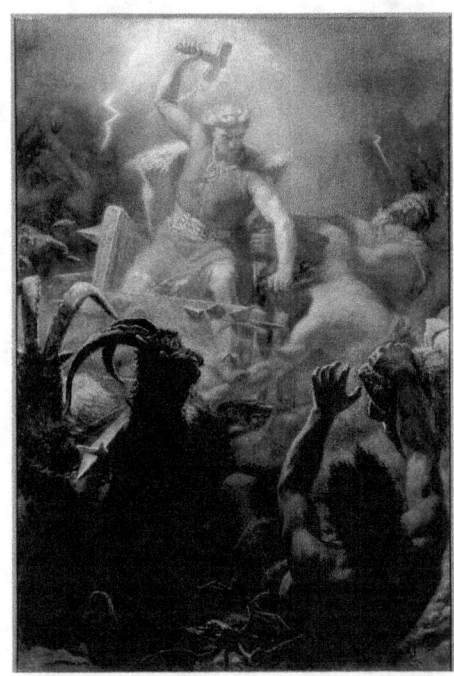

Thor's Fight with the Giants--Mårten Eskil Winge--1872

After the gods had made men and women, he noticed, far away below him, a race of small beings, some of them busy, doing mischievous deeds, while others sat idle, doing nothing. Odin sent for all these little people to come to him, and when they had reached Asgard, and were admitted to his palace of Gladsheim, they entered the great judgment hall, where they found all the Æsir sitting, with Father Odin at their head.

The little people waited in a crowd near the door, wondering what was going to happen to them, while Hermod, the messenger of the gods, ran to his master to say that they had come.

Hermod

Then the Allfather spoke to the elves about their evil deeds among men, and he told the naughtiest ones that they must go and live down underground, and look after the great furnace fire in the middle of the earth, to keep it always burning. Some must get coal to feed the fire, and others still were to have charge of the gold, and silver, and precious stones, under the rocks and only allowed to venure out by night.

"Do you not know that those who sit idle when they should be doing good deserve punishment, too?" said Odin. "I shall put you in charge of all the trees and flowers, and shall send one of the Æsir to teach you, so that you may be doing some good in the world."

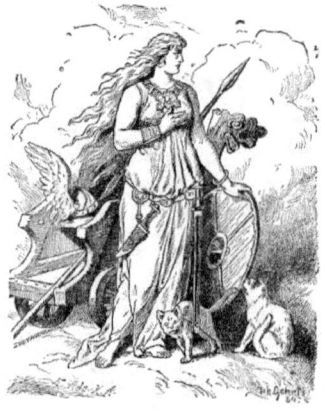

Freyja

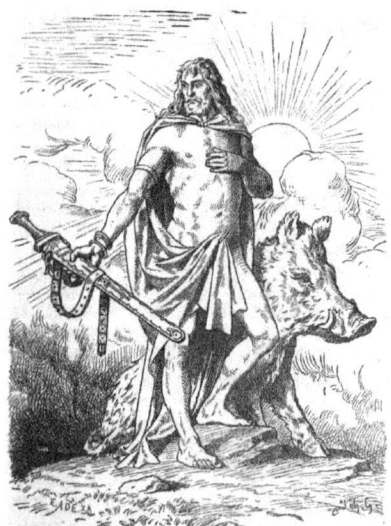

Frey

When their work was finished, and the moon had risen, these busy elves and fairies enjoyed many a happy evening, dancing and frisking on the green by moonlight, and so our world of Midgard was filled with busy work and play.

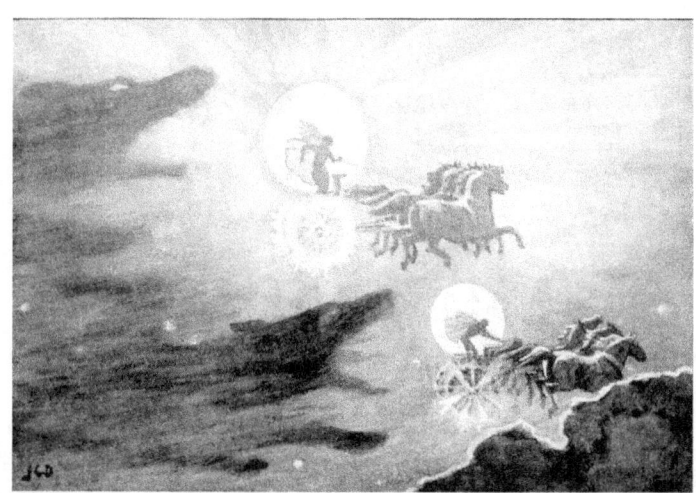

Sól (Sun) and Máni (Moon) are chased by the wolves Sköll and Háti in *The Wolves Pursuing Sol and Mani*-- J. C. Dollman --1909

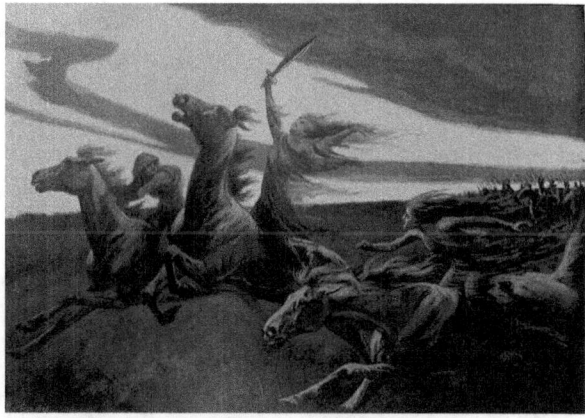

The Dises by Dorothy Hardy

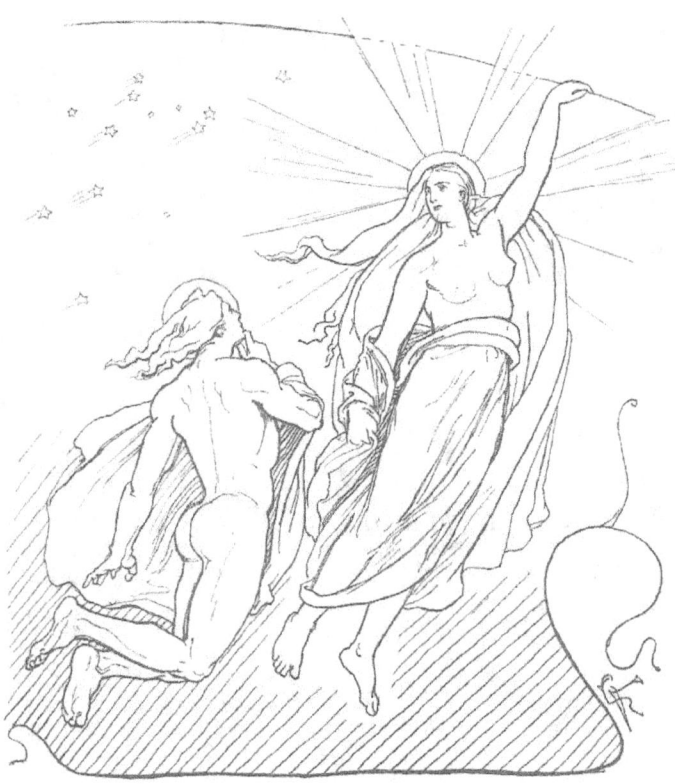

A depiction of Máni and Sól-- Lorenz Frølich--1895

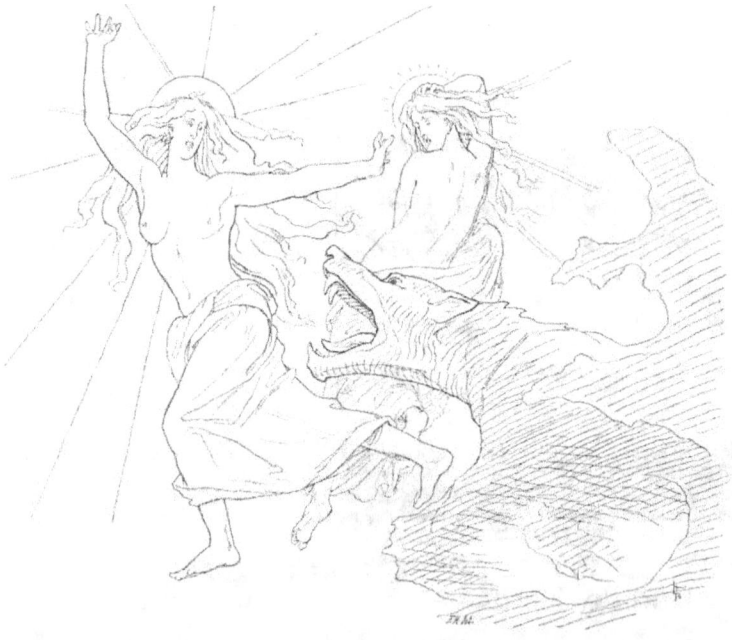

A depiction of Sól, her daughter, and the wolf Fenrir--Lorenz Frølich--1895

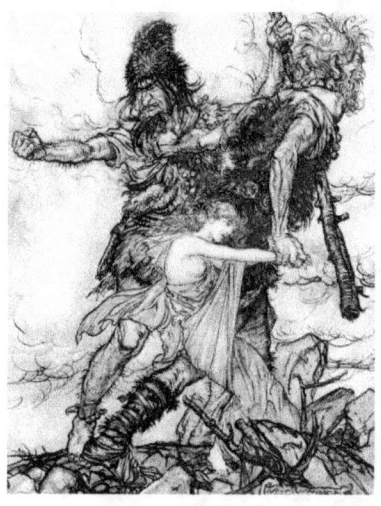

The jötnar Fafner and Fasolt seize Freyja in Arthur Rackham's illustration to Richard Wagner's Der Ring des Nibelungen

Aslaug (as Kraka)-- Marten Eskil Winge--1862.

Giantesses Fenja and Menja from an engraving-- Carl Larsson--1886--for the poem Grottasöngr

Nymphen--Hans Heyerdahl--1890

Ruhende Nymphe --Anselm Feuerbach--1870

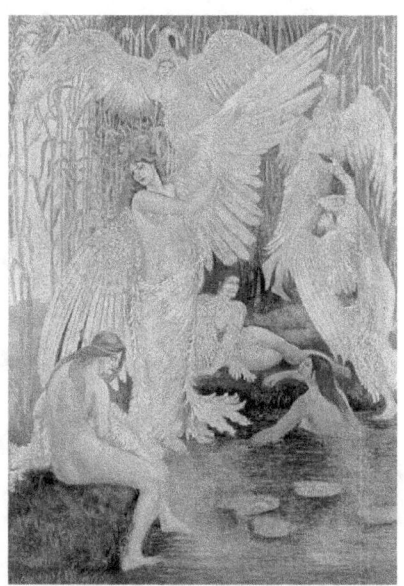

The Swan Maidens-- Walter Crane

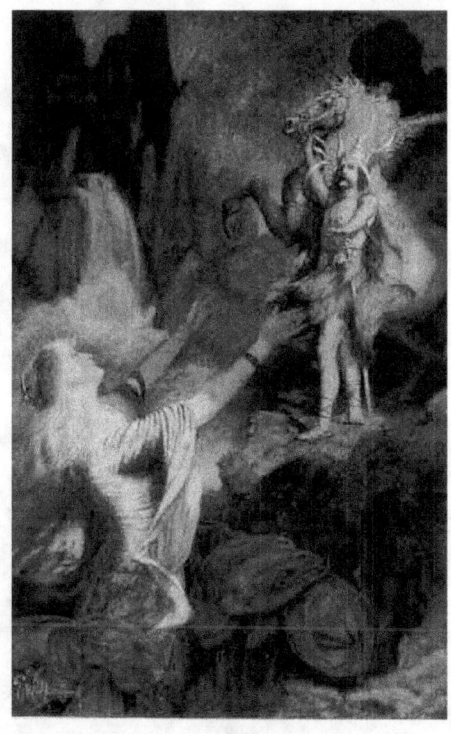

Hundingsbane's Return to Valhal-- Ernest Wallcousins--1912

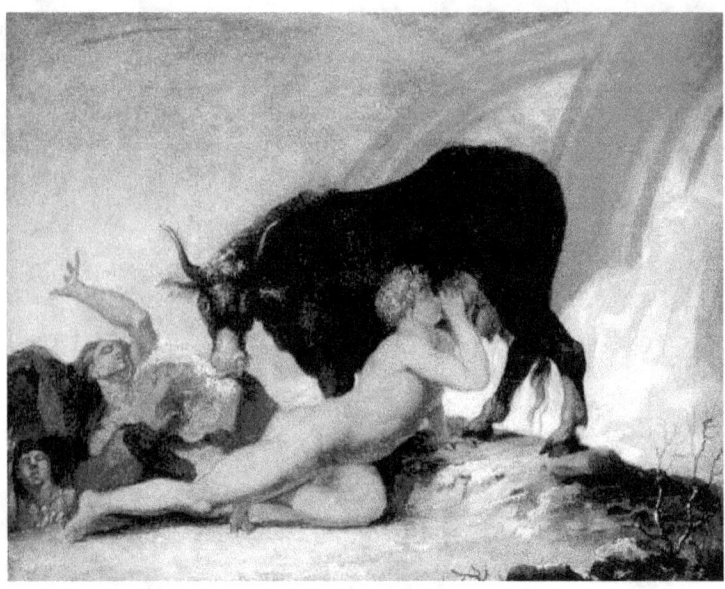

Ymir and the cow Auðhumla--Nicolai Abildgaard--1790

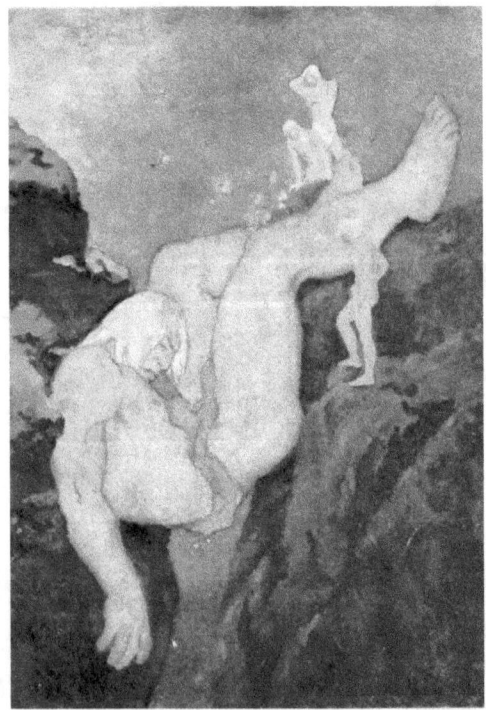

Ymir & the Sons of Burr-- Katharine Pyle--1930

Baldr secretly watches Nanna bathing-- Louis Moe--1898

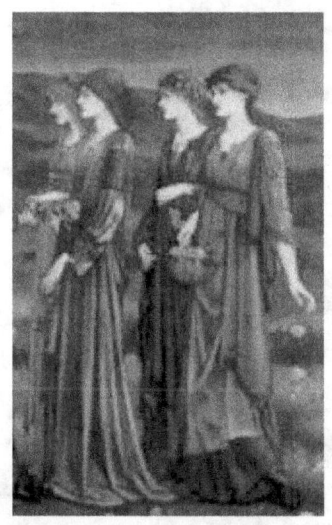

Vár is a goddess associated with oaths and agreements

In Norse mythology, Ragnarök is a series of future events, foretold that would result in the death of a number of major figures as the gods Odin, Thor, Týr, Freyr, Heimdallr, and Loki.

Afterward, the world would resurface and the surviving and returning gods will meet, and the world will be repopulated by two human survivors.

Lífþrasir and Líf are the two surviving humans that survived by hiding in a wood called Hoddmímis holt. This is mentioned in the *Poetic Edda*

Valkyries

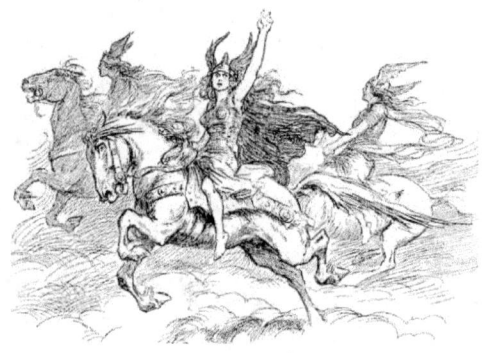

Valkyries are female spirits that choose those who may die in battle.

"choosers of the fallen"

Valhalla (Valhöll) is a majestic, enormous hall located in Asgard, ruled over by the god Odin where half that die in battle go to led by the valkyries; while the other half go to Fólkvangr which is ruled by the goddess Freyja. Valkyries also appear as lovers of heroes and other humans. When they are lovers of humans they are sometimes described as the daughters of royalty.

Half the slain
she chooses each day
and half belong to Odin.
(*Grimnismal* 14)

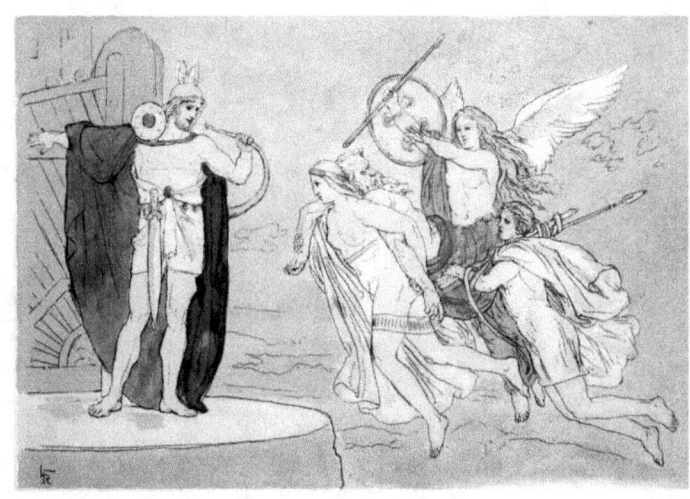

THREE VALKYRIES BRING THE BODY OF A SLAIN WARRIOR TO VALHALLA MET BY HEIMDALLR--
LORENZ Lorenz Frølich--1908

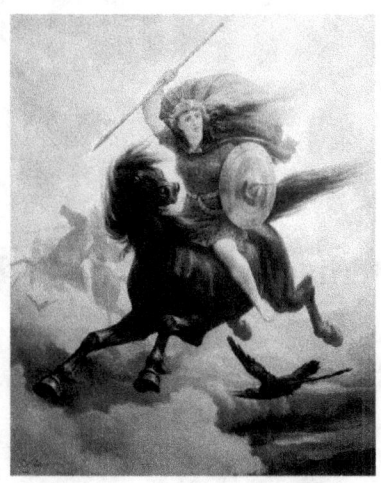

Valkyrien--Peter Nicolai Arbo--1869

Valkyries are sometimes called swan maidens.

THE VALKYRIE SIGRDRIFA SAYS A PAGAN NORSE PRAYER IN POEM Sigrdrífumál

--ARTHUR RACKHAM--1911

SHIELDMAIDENS

Shieldmaiden in Norse folklore were woman warriors.

Hervor dying after the Battle of the Goths and Huns--Peter Nicolai Arbo

Valkyrie--TheBastardSon

Lagertha

Lagertha was, a Viking shieldmaiden and the onetime wife of the famous Viking Ragnar Lothbrok as describedd by the chronicler Saxo in the 12th century.

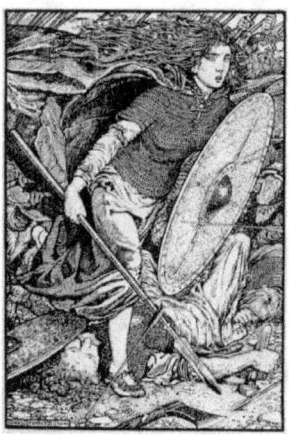

Lagertha, lithography by Morris Meredith Williams --1913

Shield and Valkyrie Brynhildr

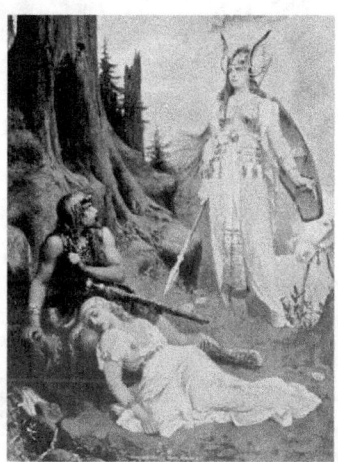

Brunhild and Siegmund--J. Wagrez

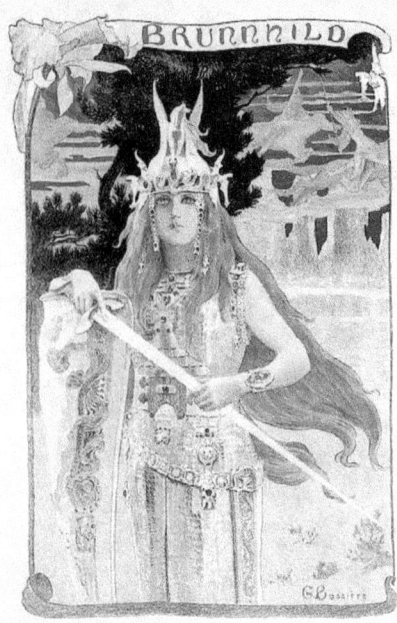

Brynhild --Gaston Bussière--1897

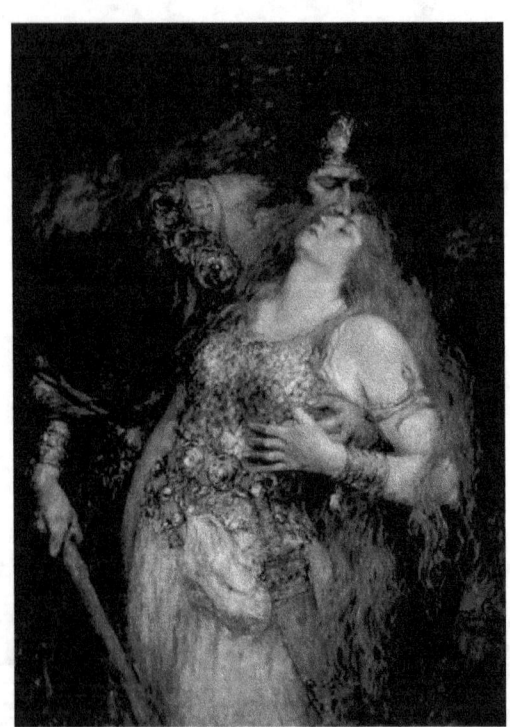

The Last Farewell of Wotan and Brunhilde -- Ferdinand Leeke--1875

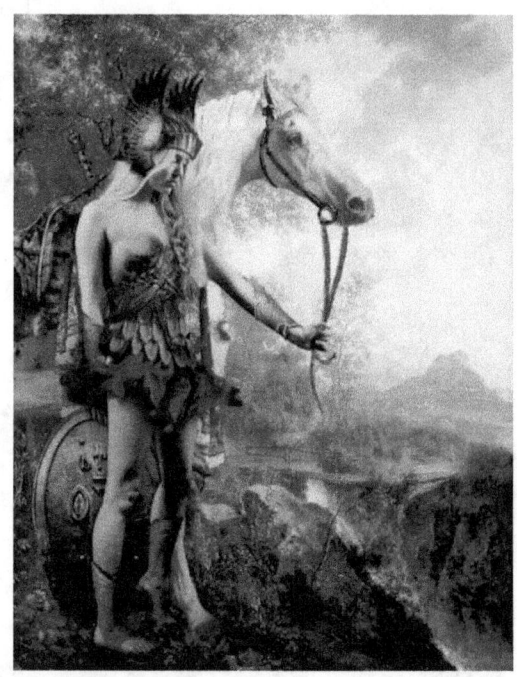

The Coming of Brunhilde--Howard David Johnson

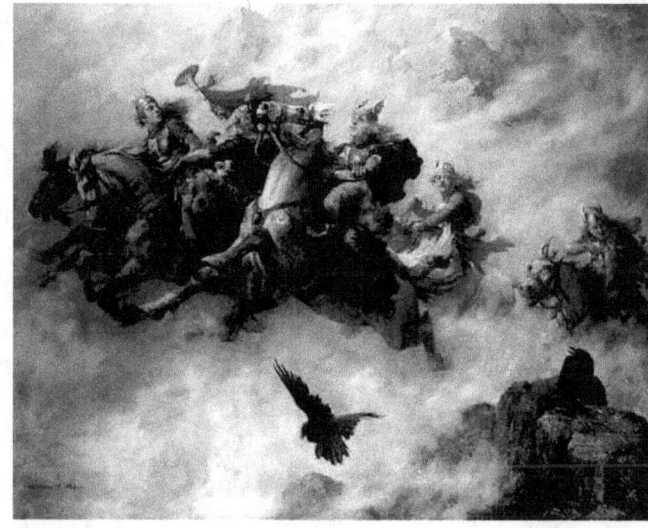

The Ride of the Valkyries--William T. Maud--1890

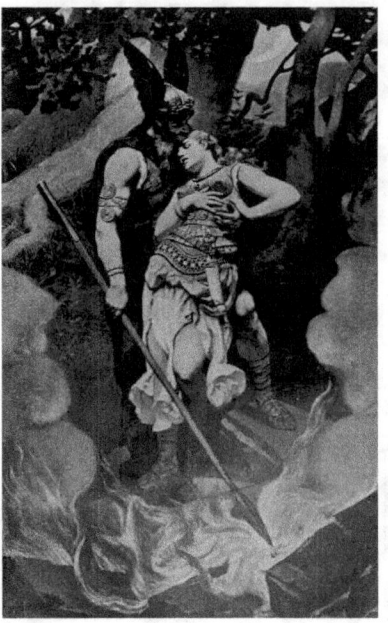

Odin and Brunhild --K. Dielitz--1892

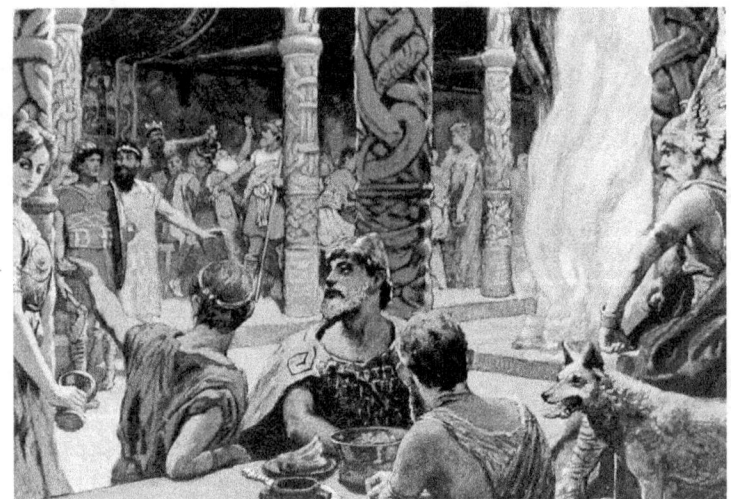

Einherjar are served by Valkyries -- Emil Doepler--1905

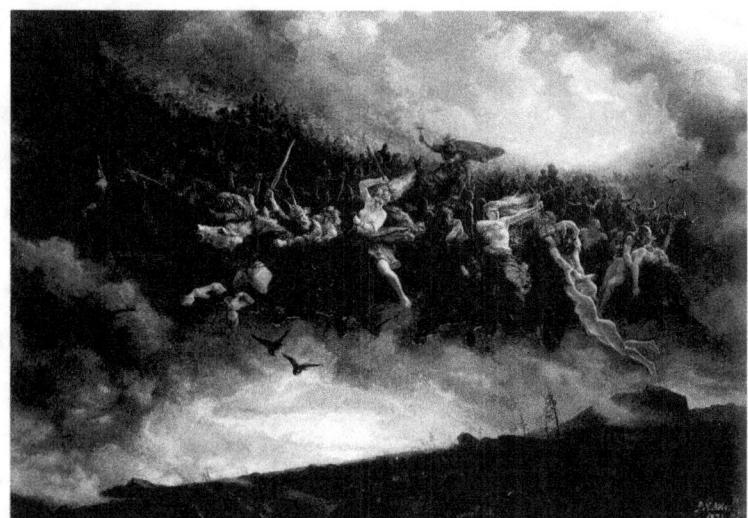
Asgardsreien--Peter Nicolai Arbo-1872

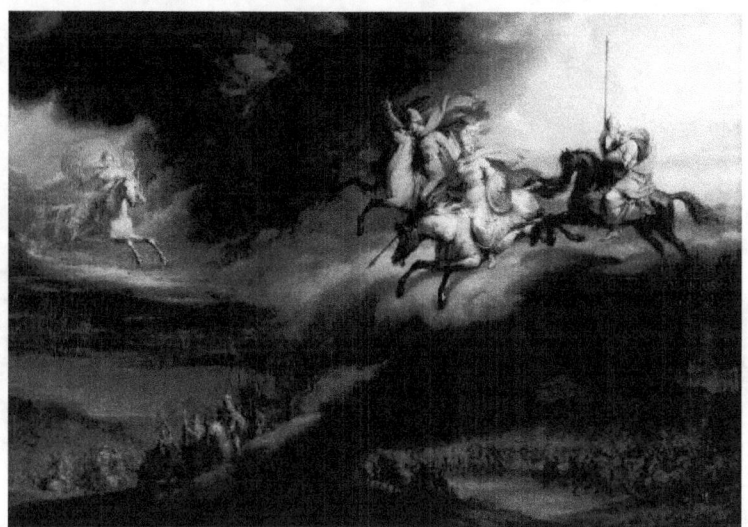
Valkyriornas Ride --Johan Gustaf Sandberg--1818

Valkyrie Maiden--Howard David Johnson

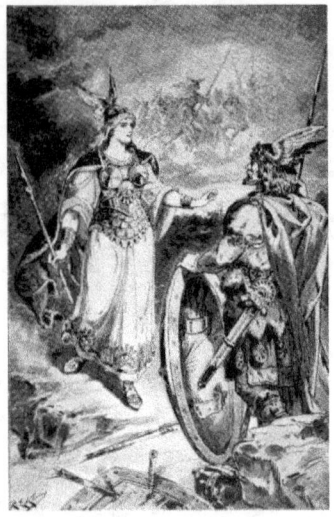

Sigrun and Helgi

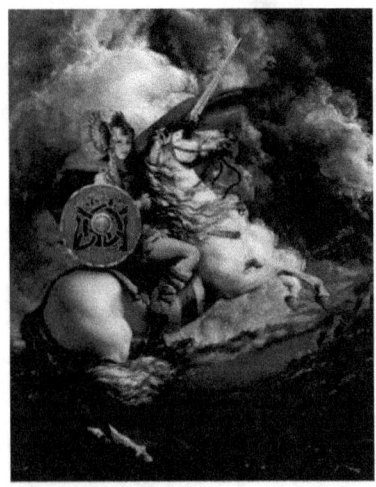

Viking War goddess--Howard David Johnson

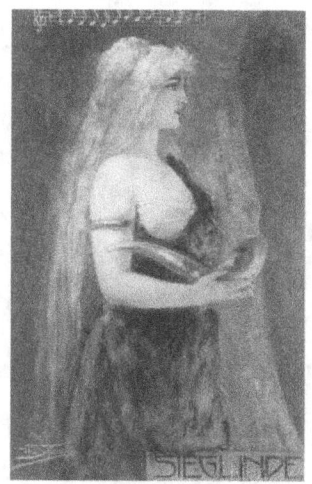

Wagner, Valkyrie--Ferdinand Leeke

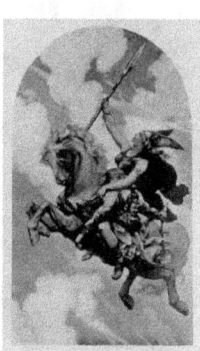

Valkyrie bearing Hero to Valhalla--K. Dielitz

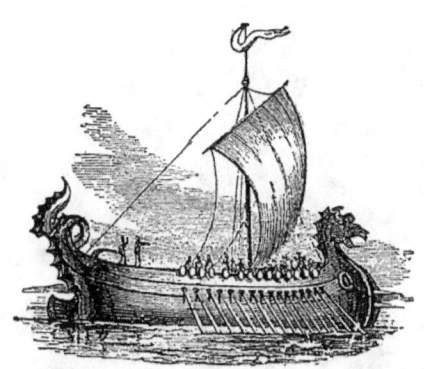

A NORSE GALLEY.

VALKYRIES' SONG.

The Sea-king looked o'er the brooding wave;
 He turned to the dusky shore,
And there seemed, through the arch of a tide-worn cave

A gleam, as of snow, to pour;
 And forth, in watery light,
 Moved phantoms, dimly white,
Which the garb of woman bore.
Slowly they moved to the billow side;
 And the forms, as they grew more clear,
Seemed each on a tall, pale steed to ride,
 And a shadowy crest to rear,
 And to beckon with faint hand,
 From the dark and rocky strand,
 And to point a gleaming spear.
Then a stillness on his spirit fell,
 Before th' unearthly train,
For he knew Valhalla's daughters well,
 The Choosers of the slain!
 And a sudden rising breeze
 Bore, across the moaning seas,
 To his ear their thrilling strain.

"Regner! tell thy fair-haired bride
She must slumber at thy side!
Tell the brother of thy breast,
Even for him thy grave hath rest!
Tell the raven steed which bore thee,
When the wild wolf fled before thee,
He too with his lord must fall,—
There is room in Odin's Hall!"
There was arming heard on land and wave,
 When afar the sunlight spread,
And the phantom forms of the tide-worn cave
 With the mists of morning fled;
 But at eve, the kingly hand
 Of the battle-axe and brand,
Lay cold on a pile of dead!—Hemans.

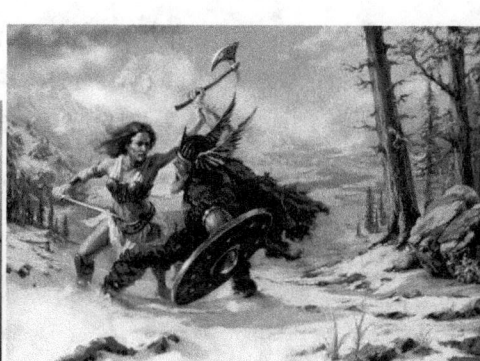

ODIN'S REWARD

ONE night when all was quiet in Asgard and the Æsir had gone to rest, Odin, the Allfather, sat awake on his high throne, troubled with many thoughts. At his feet crouched his two faithful wolves, and upon his shoulders perched the two ravens of thought and memory, who flew far abroad every day, through the nine worlds, as Odin's messengers.

The Allfather had need of great wisdom in ruling the worlds; after thinking a long time on the matters which needed his care, he suddenly started up, and went forth with long strides from his palace of Gladsheim into the night. He soon returned, leading his beautiful, eight-footed steed, Sleipnir, and it was plain that Odin was going on a journey. He quickly mounted Sleipnir--a eight-legged horse and rode swiftly away toward Bifröst, the rainbow bridge, which reached from Asgard, the city of the gods, down through the air to the lower worlds.

Odin and Sleipnir--John Bauer--1911

Soon Odin saw Heimdall, the watchman of the bridge, riding toward him on a fine horse, with a golden mane that reflected light upon the noble face of his rider.

"You must be bound on some important errand, Father Odin, to be riding forth from Asgard so late at night," said Heimdall.

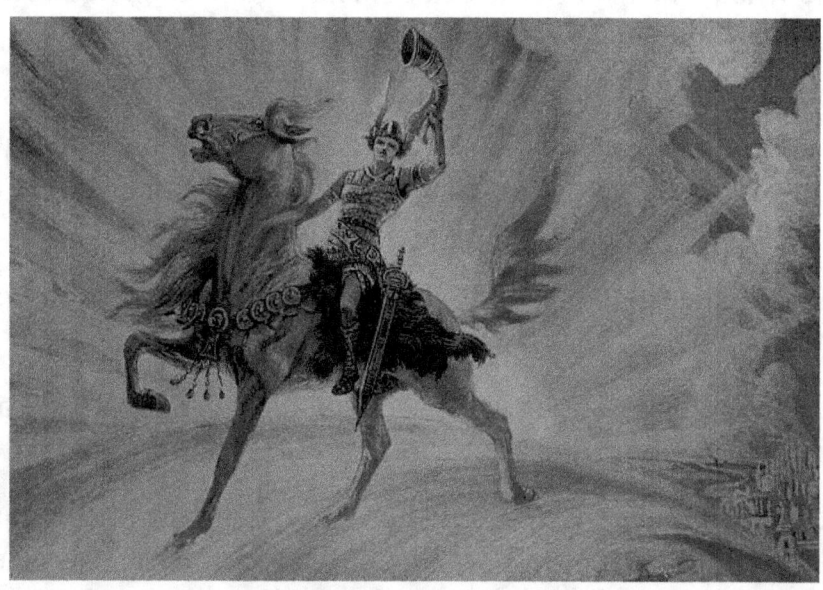

Heimdall--Dorothy Hardy

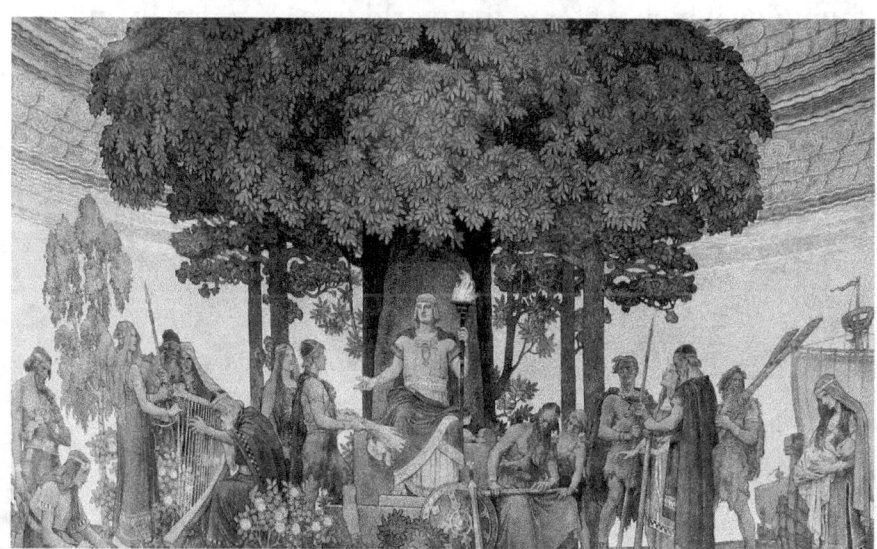

Heimdallr brings forth the gift of the gods to mankind--Nils Asplund--1907

"It is indeed a most important errand, and I must hasten on," replied Odin. "It is well for us that we have such a faithful guardian of the 'trembling bridge'; if it were not for you, Heimdall, our enemies might long ago have taken Asgard by storm. You are so watchful, you can hear the grass grow in the fields, and the wool gather on the backs of the sheep, and you need less sleep

than a bird. I myself stand in great need of wisdom, in order to take care of such faithful servants, and to drive back such wicked enemies!"

They hurried over the bridge until they came to Heimdall's far-shining castle, at the farther end of it. This was a lofty tower which was placed so as to guard the bridge, and it sent forth into the land of the giant enemies such a wonderful, clear light, that Heimdall could see, even in the darkest night, anyone who came toward the bridge. Here Odin stopped a few moments to drink the mead which the good Heimdall offered him.

Then said Odin, "As I am journeying into the land of our enemies, I shall leave my good horse with you; there are not many with whom I would trust him, but I know that you, my faithful Heimdall, will take good care of him. I can best hide myself from the giants by going on as a wanderer."

With these words the Allfather quitted Heimdall's castle, and started off toward the north, through the land of the fierce giants.

During all the first day there was nothing to be seen but ice and snow; several times Odin was nearly crushed as the frost giants hurled huge blocks of ice after him.

The second day he came to mountains and broad rivers. Often when he had just crossed over a stream, the mountain giants would come after him to the other bank, and when they found that Odin had escaped them, they would send forth such a fierce yell, that the echoes sounded from hill to hill.

At the end of the third day, Odin came to a land where trees were green and flowers blooming. Here was one of the three fountains which watered the world tree, Yggdrasil, and near by sat the wise giant, Mimir, guarding the waters of this wonderful fountain, for whoever drank of it would have the gift of great wisdom.

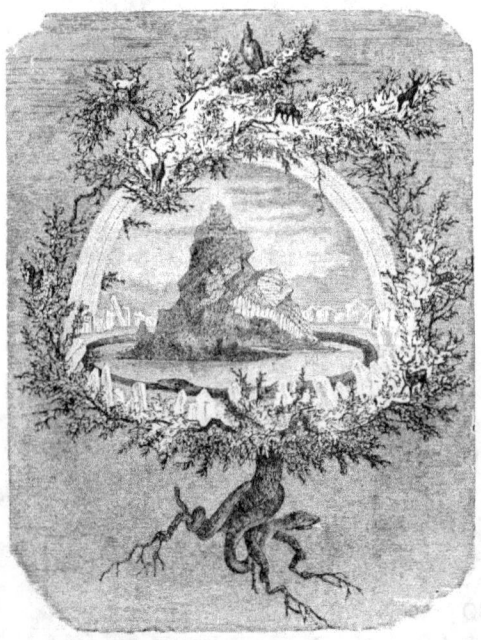

The Ash Yggdrasil--Friedrich Wilhelm Heine--1886

Mimir was a giant in size, but he was not one of the fierce giant enemies of the gods, for he was kind, and wiser than the wisest.

Mimir's well of wisdom was in the midst of a wonderful valley, filled with rare plants and bright flowers, and among the groves of beautiful trees were strange creatures, sleeping dragons, harmless serpents, and lizards, while birds with gay plumage flew and sang among the branches. Over all this quiet valley shone a lovely soft light, different from sunlight, and in the center grew one of the roots of the great world tree. Here the wise giant Mimir sat gazing down into his well.

Odin drinks from Mímisbrunnr (well) as Mímir looks on (1903) in a work by Robert Engels

Odin greeted the kind old giant, and said, "Oh, Mimir, I have come from far-away Asgard to ask a great boon!"

"Gladly will I help you if it is in my power," said Mimir.

"You know," replied Odin, "that as father of gods and men I need great wisdom, and I have come to beg for one drink of your precious water of knowledge. Trouble threatens us, even from one of the Æsir, for Loki, the fire-god, has lately been visiting the giants, and I fear he has been learning evil ways from them. The frost giants and the storm giants are always at work, trying to overthrow both gods and men; great is my need of wisdom, and even though no one ever before has dared ask so great a gift, I hope that since you know how deep is my trouble, you will grant my request."

An anonymous painting of Loki from an Icelandic illuminated manuscript

Mimir sat silently, thinking for several moments, and then said, "You ask a great thing, indeed, Father Odin; are you ready to pay the price which I must demand?"

"Yes," said Odin, cheerfully, "I will give you all the gold and silver of Asgard, and all the jeweled shields and swords of the Æsir. More than all, I will give up my eight-footed horse Sleipnir, if that is needed to win the reward."

"And do you suppose that these things will buy wisdom?" said Mimir. "That can be gained only by bearing bravely, and giving up to others. Are you willing to give me a part of yourself? Will you give up one of your own eyes?"

At this Odin looked very sad; but after a few moments of deep thought, he looked up with a bright smile, and answered, "Yes, I will even give you one of my eyes, and I will suffer whatever else is asked, in order to gain the wisdom that I need!"

We cannot know all that Odin bravely suffered in that strange, bright valley, before he was rewarded with a drink from that wonderful fountain; but we may be quite sure that never once was the good Allfather sorry for anything he had given up, or any suffering he had borne, for the sake of others.

Tyr and the Wolf

I.

Odin, the Allfather, sat one day on his high air-throne, and looking around him, far and wide, saw three fierce monsters. They were the children of the mischievous fire-god Loki, and Odin began to feel anxious, for they had grown so fast and were getting so strong that he feared they might do harm to the sacred city of Asgard. The wise father knew Loki had given strength to these dreadful creatures, and he saw that all this danger had come upon the Æsir from Loki's wickedness.

One of these monsters was a huge serpent, that Odin sent down into the ocean, where he grew so fast that his body was coiled around the whole world, and his tail grew into his own mouth. He was called the Midgard serpent.

The second monster was sent to Niflheim, the home of darkness, and shut up there.

The third, a fierce wolf, named Fenrir, was brought to Asgard, where Odin hoped he might be tamed by living among the Æsir, and seeing their good deeds, and hearing their kind words; but he grew more and more fierce, until only one of all the gods dared to feed him. This was the brave god, Tyr. He was a war-god, like Thor, and is sometimes called the Sword-god. Tyr was loved by all because he was so true and faithful.

Each day the dreadful wolf grew larger and stronger, till all at once, before the Æsir thought about it, he had become a very dangerous beast.

Father Odin always looked troubled when he saw Fenrir, the wolf, come to get his evening meal of meat from Tyr's hand, and at last one night, after the wolf had gone growling away to his lair, Odin called a meeting of the Æsir. He told them of his fears, saying they must find some

plan for guarding themselves and their home against this monster. They could not slay him, for no one must ever be killed, and no blood must be shed, within the walls of the sacred city.

Thor was the first to speak: "Do not fear, Father Odin, for by to-morrow night we shall have Fenrir so safely bound that he cannot do us any harm. I will make a mighty chain, with the help of my hammer, Miölnir, and with it we will bind him fast!"

When the Æsir heard these words of Thor, they were glad, and all went home rejoicing—all save the Allfather, who was still troubled, for he well knew the danger, and feared that even the mighty Thor would find this task too much for him. But Thor seized his hammer, and strode off to his forge. There he worked the whole night long, and all through Asgard were heard the blows of Miölnir and the roaring of the bellows.

The next night, when the Æsir were gathered together, Thor brought forth his new-made chain, to test it. In came Fenrir, the wolf, and everyone was surprised to see how willingly he let himself be bound with the chain. When Thor had riveted the last links together, the gods smiled, and began to praise him for his wonderful work; but all at once the wolf gave one bound forward, broke the great chain, and walked off to his lair as if nothing had happened.

Thor was much disappointed, still he did not lose courage. He said to the Æsir that he would make another chain, yet stronger. Again he set to work, and for three nights and three days the great Thor worked at his forge without resting.

While he worked his friends did not forget him. They came and looked on while he was busy, and, as they watched the mighty hammer falling with quick blows upon the metal, they talked to Thor or sang noble songs to cheer him; sometimes they brought him food and drink. One visitor, who was no friend, fierce Fenrir, the wolf, sometimes put his nose in at the door for a moment, and watched Thor at work; then, as he went away, Thor heard a strange sound like a wicked laugh.

At last the chain was finished, and Thor dragged it to the place of meeting. It was so heavy that even the mighty Thor could hardly lift it, or drag it as far as Odin's palace of Gladsheim. This time Fenrir was not so willing to be bound; but the gods coaxed him, and talked of his great strength, and told him they were sure he would easily break this chain also. After a while he agreed to let them put it around his neck.

This time Thor was sure the chain would hold firm, for never before had such a strong one been made. But soon, with a great shake and a fierce bound, the wolf broke away, and went off to his lair, snarling and showing his wicked teeth, while the broken chain lay on the ground.

Sadly the Æsir came together that night in Odin's palace, and this time Thor was not the first to speak; he sat apart and was silent.

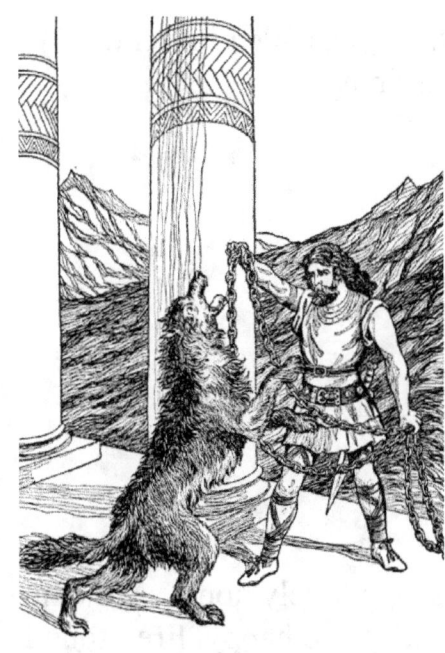

THOR CHAINING FENRIR.

First spoke Frey, the god of summer and king of the fairies. "Hearken to me, O lords of Asgard!" he said. "I have not won a brave name in battle, like the noble Tyr, neither have I done such mighty deeds as the great Thor and others of our heroes. Instead of fighting giants and monsters, I have spent most of my life in the woods, among the flowers, listening for hours to the birds. Many things have I watched, some perhaps that my brothers thought too small to be worthy of notice. I have learned many lessons, and the greatest of them all is to know how much power there is in little things, and to see how often the work, done quietly, and hidden from the eyes of men, is the finest and the most wonderful. Since we cannot make a chain strong enough to bind Fenrir, let us go to the little elves, who work in silence and in darkness, and ask them to make us a chain!"

The Allfather's troubled face grew brighter as he heard Frey speak, and he bade him send a messenger quickly to the elves, to order a chain made as soon as possible.

II.

So Frey went out, leaving the Æsir in their trouble, and came to his own lovely home, Alfheim. There everything was bright and peaceful, and the little elves were busy and happy. Frey found a trusty messenger, and sent him with all speed to the little people underground, to order the new chain, and to return as soon as he could bring it. The faithful servant found the funny little fay workmen all busy in their dark rock chambers, far down inside the earth, while at one side, in a lighter place, sat their king. The messenger bowed before him, and told him his errand.

The elfins were a wicked race, but they were afraid of Odin, for they had not forgotten the talk he once had with them, when he sent them down to work in darkness underground, and since that time they never had dared disobey him. The elf king said it would take two days and two nights to make the chain, but it would be so strong that no one could break it.

While the busy gnomes were at work, the messenger looked about at the many wonderful things: the great central fire which burns always in the middle of the earth, watched and fed with coal by the elves; above this, the beds of coal, and bright precious diamonds, which the elves took from the ashes of the fire. In another place he watched them putting gold and silver, tin and copper, into the cracks in the rocks, and he drank of the pure, underground water, which gives the Midgard (home of people) people fresh springs.

After two days this messenger returned to the fay king. The king, holding out in his hand a fine, small chain, said to the messenger: "This may seem to you to be small and weak; but it is a most wonderful piece of work, for we have used in it all the strongest stuff we could find. It is made of six kinds of things: the noise made by the footfall of cats, the roots of stones, the beards of women, the voice of fishes, the spittle of birds, the sinews of bears. This chain can never be broken; and if you can once put it on Fenrir, he will never be able to throw it off."

Odin's messenger was glad to hear this, so he thanked the elf king, and promising him a large reward, he went on his way back to Asgard, where the Æsir were longing for his return, and were all rejoiced to see him with the magic chain.

Now Father Odin feared that Fenrir would not let them bind him a third time, so he proposed they should all take a holiday, and go out to a beautiful lake to the north of Asgard, where they

would have games and trials of strength. The other gods were pleased with this plan, and all set out in Frey's wonderful ship, which was large enough to hold all the Æsir with their horses, and yet could be folded up small enough to go in one's pocket.

They landed on a lovely island in the lake, and after the races and games were over, Frey brought out the little chain, and asked them all to try to break it. Thor and Tyr tried in vain; then Thor said, "I do not believe anyone but Fenrir can break it."

Now the wolf did not want to be bound again; but he was very proud of his strength, and, for fear of being called a coward, said at last he would let them do it, if he might hold the right hand of one of the Æsir in his mouth while they bound him, as a sign that the gods did not mean to play any tricks.

When the gods heard this, they looked at each other, and all but one of them drew back. Only the brave, good Tyr stepping forward, quietly put his hand into Fenrir's mouth. The other gods then put the chain around the beast, and fastened it to a great rock. The fierce creature gave a leap to free himself, but the more he struggled the tighter grew the chain. The Æsir gathered about him in joy to see this, but their hearts were filled with sorrow when they saw that their noble Tyr had lost his right hand; the dreadful wolf had shut his teeth together in his rage, when he found he could not get free.

Thus the brave Tyr dared to risk danger for the sake of saving others, and gave up even his right hand to gain peace and happiness for Asgard.

Freyja's Necklace

Freyja is a goddess affliated with love, sex, beauty, fertility, gold, seiðr, war, and death. Freyja has the necklace Brísingamen, rides a chariot pulled by two cats, has the boar Hildisvíni by her side, and has a cloak of falcon feathers. Her and Óðr has two daughters, Hnoss and Gersemi.

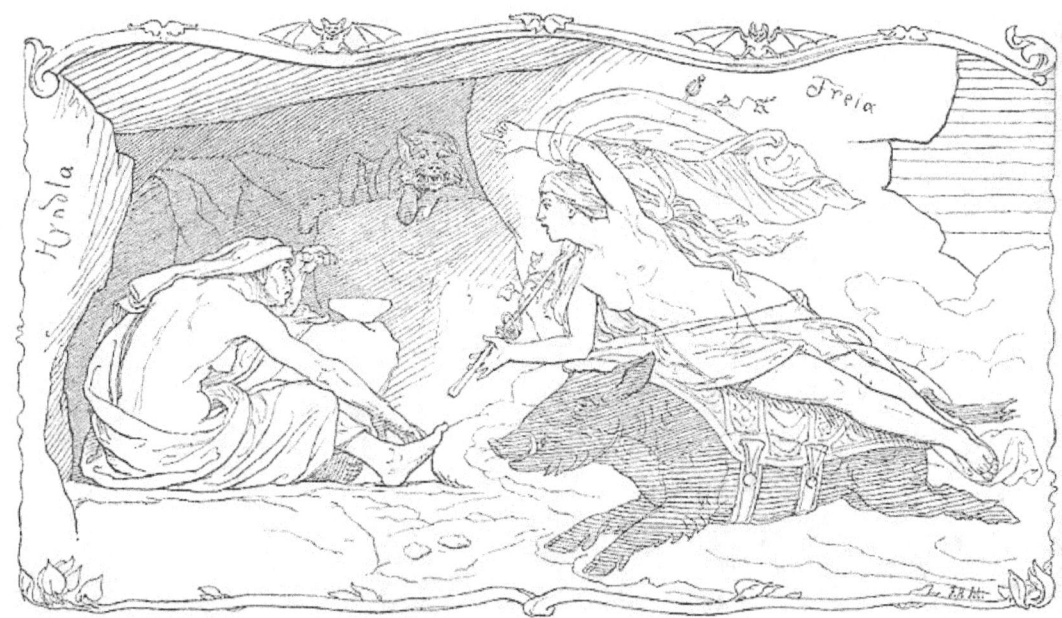
The goddess Freyja with her boar Hildisvíni go to see Hyndla, as attested in Hyndluljóð

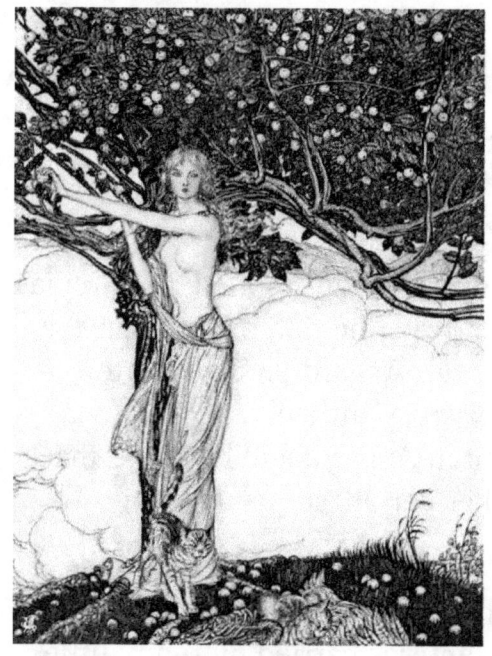
Freyja, in an illustration to Wagner's operas by Arthur Rackham

Freya--Penrose

"Yes, I really must have some flowers to wear to the feast to-night," said Freyja to her husband, Odur.

Freyja was the was the most beautiful of all the Æsir, and everyone loved to look at her charming face, and to hear her sweet voice.

"I think you look quite beautiful enough as you are, without flowers," Odur replied, but Freyja was not satisfied; she thought she would go and find her brother Frey, the god of summer, for he would give her a garland of flowers. So she wandered forth from Asgard on her way to Frey's bright home in Alfheim, where he lived among his happy, busy little elves. As Freyja walked along she was thinking of the feast to be given that night in Asgard, and knowing that all the gods and goddesses would be there, she wished to look her very best.

On and on she wandered, not thinking how far she was getting away from home. Finally the light began to grow fainter and fainter, and Freyja found herself in a strange place. The sunlight had faded away, but there was still a little light that came from lanterns carried by funny little elves, who were busily working. Some were digging gold and gems, others were cleaning off the dirt from the precious stones, and polishing them to make them bright, while four little fellows were seated in one corner, putting the sparkling stones together into a wonderful necklace.

"What can that beautiful thing be?" thought Freyja. "If only I had that, it would surely make me look more beautiful than anyone else at the feast to-night!" And the more she thought about it, the more she longed to get it. "Oh, I really must have it!" she said to herself, and with these

words she stepped nearer to the four little men. "For what price will you sell me your necklace?" she asked.

The leprechauns looked up from their work, and when they saw Freyja's lovely face and heard her sweet voice, said, "Oh, if you will only look kindly upon us, and be our friend, you may have the necklace!"

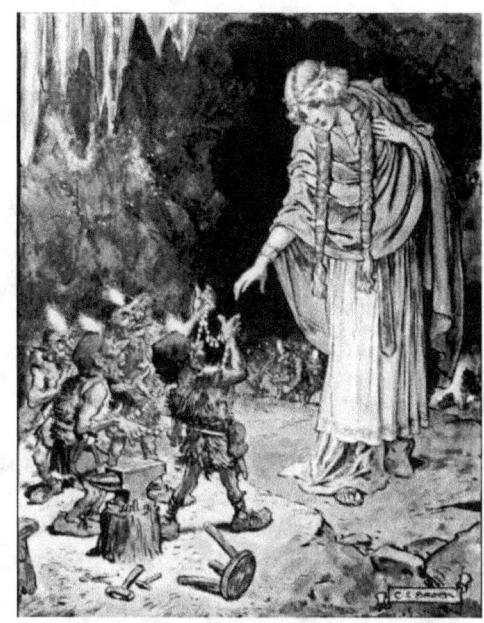

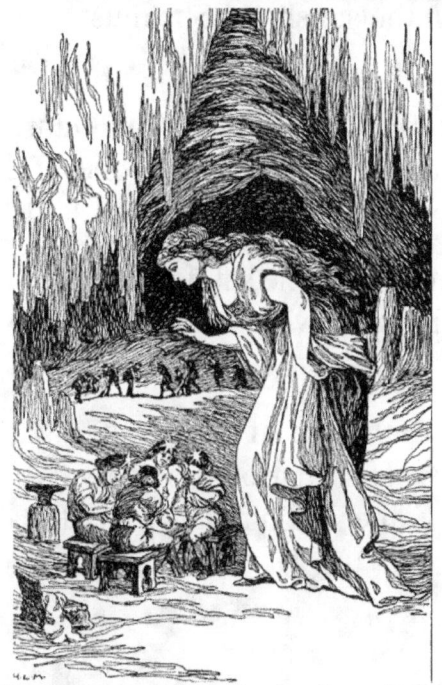

FREYJA IN THE CAVE OF THE NISSES.

Then a mocking laugh echoed again and again through the dark cavern, seeming to say, "How foolish you are to wish for these bright diamonds; they will not make you happy!" But Freyja snatched the necklace and ran out of the cavern. It did not please her to hear the teasing laugh of the elves, and she wanted to get away from them as soon as possible.

Heimdall returns Brisingamen to Freyja, in an anachronistic painting

At last she was once more out in the open air; she tried to be free and happy again, but a strange feeling of dread came over her, as if something were going to happen. Soon she came to a still pool of water, and, putting on the necklace, she bent over to look at her picture in the clear water. How beautiful the diamonds were! and how they sparkled in the sunshine! She must hasten home to show them to Odur.

The fair goddess soon reached Asgard, and hurried to the palace to find her husband. But Odur was not there. Over and over again she searched through all the rooms in vain; he had gone, and although Freyja had her beautiful necklace, she cared little for it without her dear husband.

Soon it was time to go to the feast, but Freyja would not go without Odur. She sat down and wept bitter tears; she felt no joy now for having the necklace, and no sorrow because she could not feast with the Æsir.

If only Odur would come back, all would be well again. "I will go to the end of the world to find him!" said Freyja, and she began to make ready for her journey. Her chariot, drawn by two cats, was soon ready; but before she could start, she must first ask Father Odin to allow her to go.

Freja--Anders Zorn--1901

"Allfather, I beg you give me leave to go to look for my Odur in every corner of the world!"

The wise father replied, "Go, fair Freyja, and may you find whom you seek."

Freya--Harana Janto

Freyja--Lisa Iris

Freya--NJO Blommer--1852

Freyja--Kris Waldherr

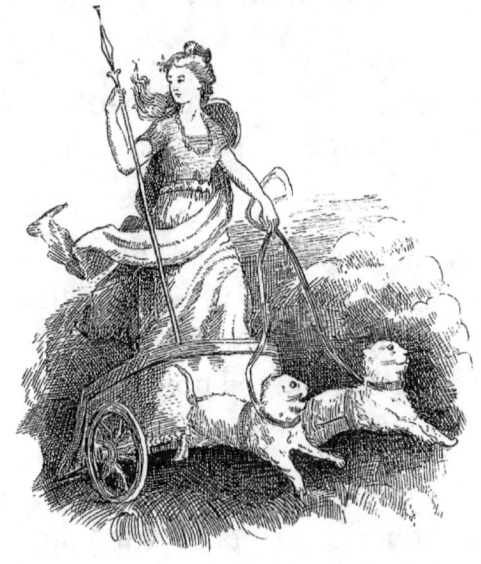

Then she started forth. First to the Midgard world the goddess of beauty went, but no one in all the world had seen or heard of Odur. Down under the earth, to Niflheim, and even to Utgard, the land of giants, she wandered, but still no one had seen or even heard of her husband. Poor Freyja wept many tears, and wherever the teardrops fell, and sank into the ground, they turned into glistening gold.

At last the sad goddess returned to her own palace alone. She still wore the wonderful necklace, which was called Brisingamen.

One night, when the hour was late, all the Æsir were asleep, except the ever watchful Heimdall, who heard soft footsteps, like those of a cat, near Freyja's palace. He listened, and thought, "That is surely someone bent on mischief; I must follow him."

When Heimdall reached the palace, he found it was Loki, changed into another form, creeping softly about. Heimdall quietly watched him, and saw him glide in to Freyja's bedside, where the fair goddess lay asleep, wearing her beautiful necklace. Loki had come to steal the necklace, but when he saw that she was lying on the clasp of the chain, so that he could not undo it without waking her, he changed himself into a gnat, and, crawling along on the pillow, stung her just enough to make her turn over, but not enough to wake her. Then he unclasped the chain and ran off with it as fast as he could.

But Heimdall was not going to let the thief get away. As soon as Loki found that he was followed, he took his other form, a little flame of fire; Heimdall then took his other shape, and became a shower of rain, to put out the fire; but Loki, quick and watchful, changed himself into a bear, to catch the rain. Then Heimdall too became a bear, and a fierce fight began. At last the rain-god conquered, and forced wicked Loki to give back the necklace to Freyja.

The whole land seemed to feel sorry for poor, lonely Freyja; the leaves fell from the trees, the bright flowers faded, and the singing birds flew away.

Once more the fair goddess went forth from Asgard to seek Odur. Away, away to the far-off sunny south she wandered, and there, where the myrtle trees and the oranges grow, at last she found her long-lost husband.

Then hand in hand the two turned northward again, to their home, and so happy were they together, that they spread joy and happiness around them as they passed along. Everywhere the ice and snow thawed before them, green grass and sweet flowers sprang up behind their footsteps, the birds sang their sweetest songs, the warm summer came back to the north lands, and everyone was glad and joyful, for lovely, smiling Freyja was at home again.

"White were the moorlands And frozen, before her; Green were the moorlands And blooming, behind her. Out of her gold locks Shaking the spring flowers, Out of her garments Shaking the south wind,Around in the birchesAwaking the throstles, Beautiful Freyja came."—KINGSLEY.

Skírnismál

The poem *Skírnismál* (*Sayings of Skírnir*) is one of the poems of the *Poetic Edda*. It tells of the god Freyr and his courting of the jötunn woman Gerðr. Freyr looks into Jötunheimr--the home of the enemies of the gods the giants and sees the pulchritudinous Gerðr and falls instantly in love with her. The lovesick Freyr becomes sullen and sad. Freyr's servant Skírnir find out what troubles his master. Freyr tells of his seemingly hopeless love for a jötunn woman. Skírnir volunteers to ride to Jötunheimr and ask for Gerðr's hand. Freyr is equipped for his journey with a horse 'so tall it can carry me through dark and leaping flames' and with his sword 'that can cut through the family tree of Jötnar'.

Skírnir rides to Jötunheimr and arrives at the house of Gymir--Gerðr's father. Angry dogs guard the fence surrounding Gymir's hall. When Gerðr hears their barking, she brings Skírnir in to drink mead and asks who he is:

Stanza 16. Gerðr:

Bid the man come in,

and drink good mead

here within our hall;

though this I fear,

that there without

my brother's slayer stands.

Stanza 17.

Art thou of the elves

or the offspring of gods,

or of the wise Vanir?

How camst thou alone

through the leaping flame

thus to behold our home?

Skírnir tells of Freyr's love for her. He offers Gerðr the apples of the gods, but she declines. Then he offers her Odin's golden ring, but also this she declines. So Skírnir tries another strategy – threatening her with the sword. Still Gerðr refuses. Finally Skírnir has to resort to a

magic staff with which he threatens to enchant Gerðr, condemning her to a pitiful life if she does not consent. Now Gerðr yields and promises to meet Freyr in the Barri grove in nine nights' time.

Stanza 39. Gerðr:

Barri there is,

which we both know well,

a forest fair and still;

and nine nights hence

to the son of Njördr

will Gerðr there grant delight.

(adapted from the translation by H.A. Bellows)

Skírnir rides home to report to Freyr about his courting expedition.

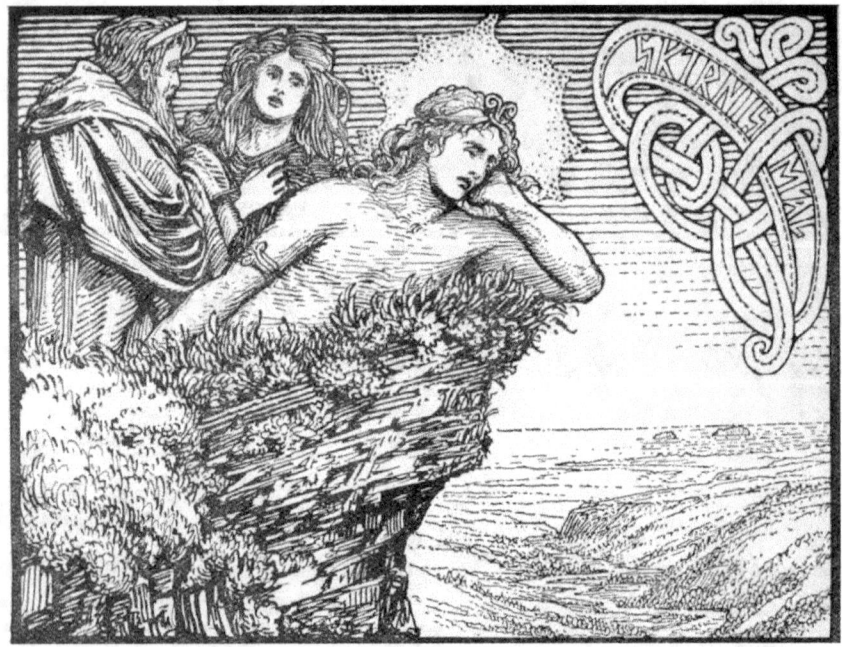

The Lovesickness of Frey --W.G. Collingwood--1908

The giant maiden laughed at Skirnir's threats

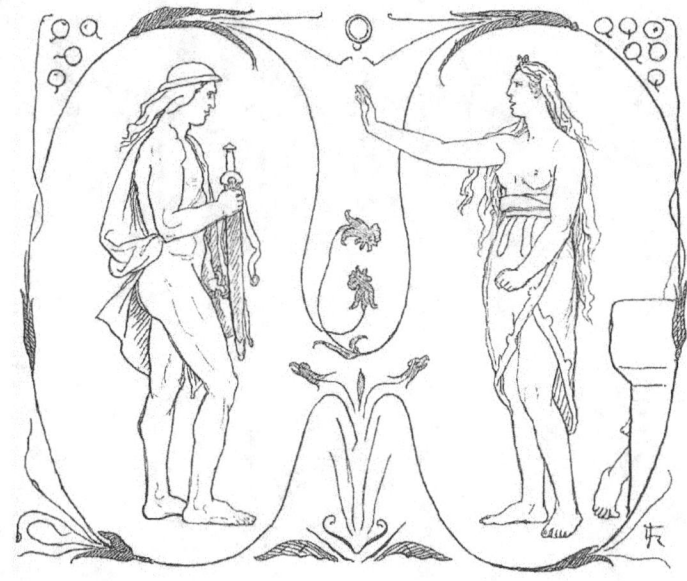

The first of three Skírnismál (Sayings of Skírnir) images by Frølich depicting Freyr's messenger Skírnir threating Gerðr.

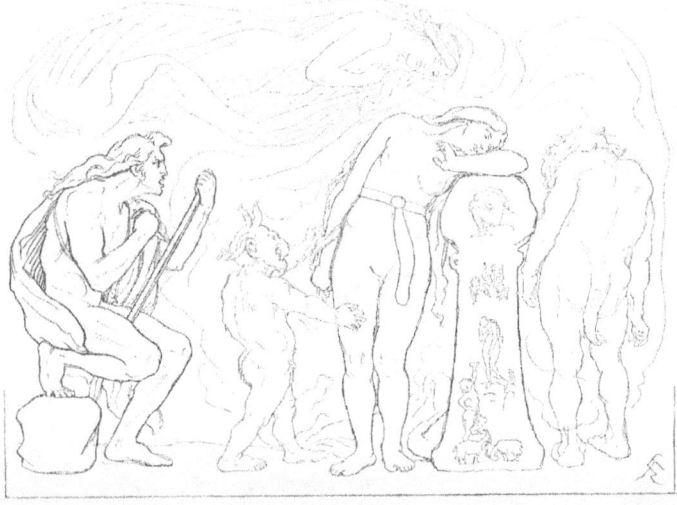

The second of three Skírnismál images by Frølich depicting Freyr's messenger Skírnir threating Gerðr.

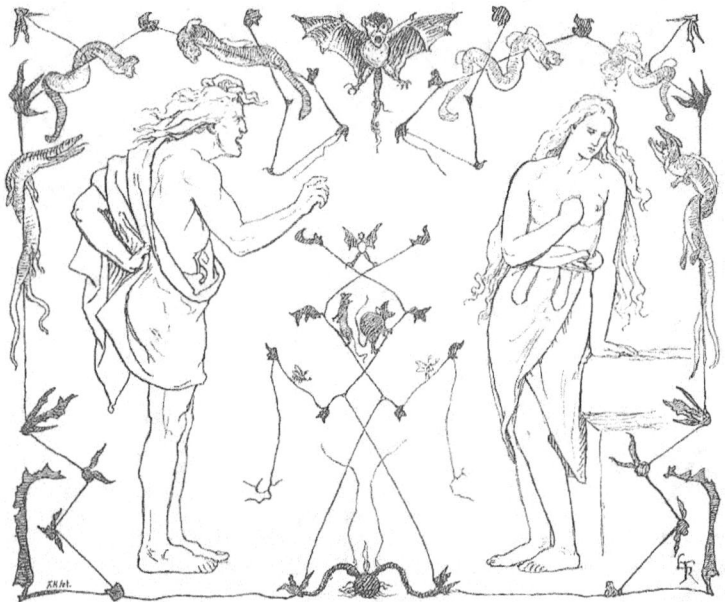

The third of three Skírnismál images by Frølich depicting Freyr's messenger Skírnir threating Gerðr.

Svipdagsmál

Svipdagsmál or *The Lay of Svipdagr* comprises two poems, *The Spell of Gróa* and *Fjölsvinnsmál* or *The Sayings of Fjölsvinnr* by the Poetic Edda.

The Spell of Gróa (Grógaldr)

In the first stanza of this poem Svipdag speaks and asks his mother to arise from beyond the grave, at her burial mound, as she had asked him do in life. The second stanza contains her response, in which she asks Svipdag why he has awakened her from death.

He responds by telling her of the task he has been set by his stepmother to win the hand of Menglöð. He states:

"she bade me travel to a place

where travel one cannot

to meet with fair Menglöð"

His dead mother agrees with him that he faces a long and onerus journey but does not attempt to expostulate him from it.

Svipdag then requests his mother to cast incarnations for his protection and she casts nine of them.

Groa's Incantation by W. G. Collingwood

Fjölsvinnsmál or *The Sayings of Fjölsvinnr*

At the start of *Fjölsvinnsmál*, Svipdagr has arrived at a castle on a mountain top. There he encounters a watchman--Fjölsviðr--who tells him to leave and then asking him his name. Svipdagr enshrouds it, only to proclaim it later in the poem.

A game of question and answers betides, wherein Svipdagr learns that Menglöð lives in the castle guarded by Fjölsviðr, and that the fortress may only be entered by someone named Svipdagr. He gives his bona fide name and the gates are opened and goddess Menglöð greets Svipdagr.

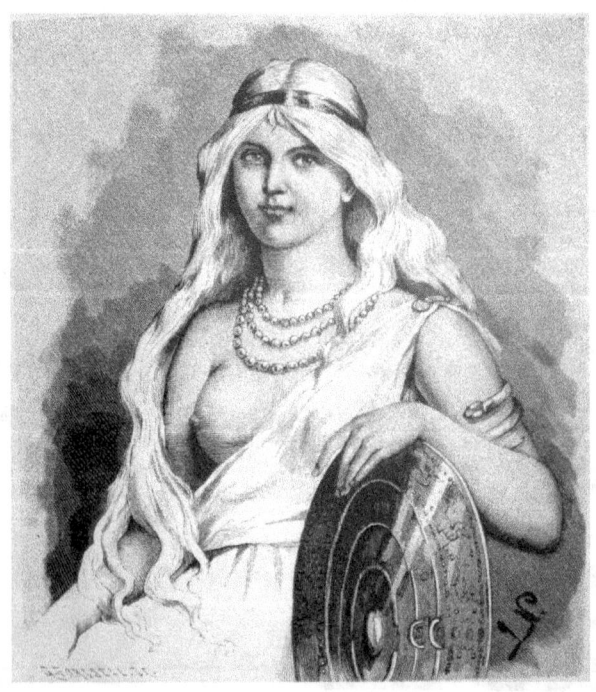

Menglöð

Sinmara--Jenny Nyström--1893

Svipdagr meets his beloved in this illustration--W. G. Collingwood.

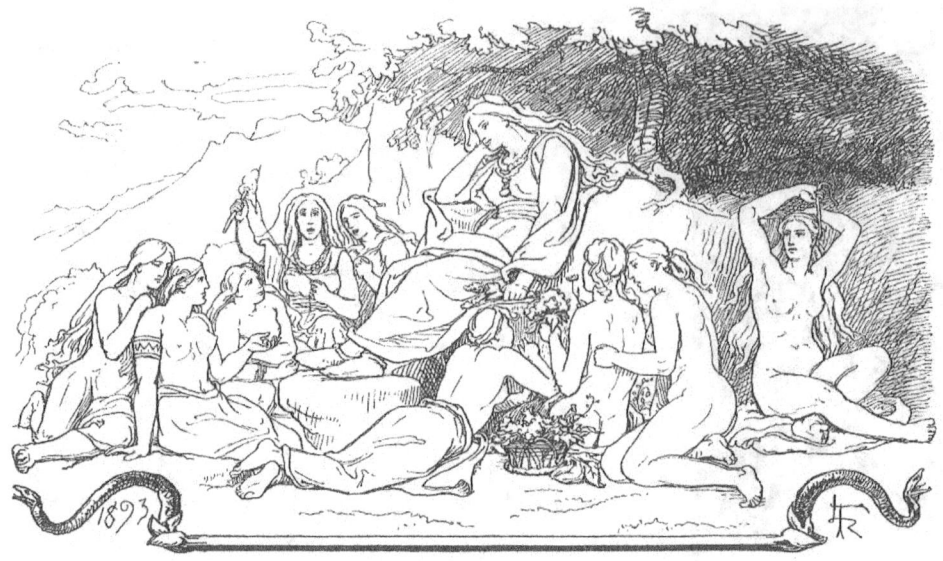

Menglöð sits with the nine maidens, on Lyfjaberg--1893--Lorenz Frølich.

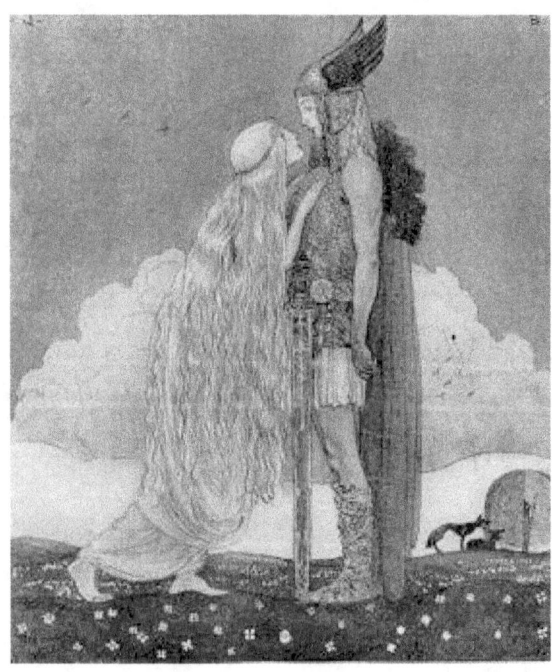

Svipdag and Menglöð--John Bauer--1907

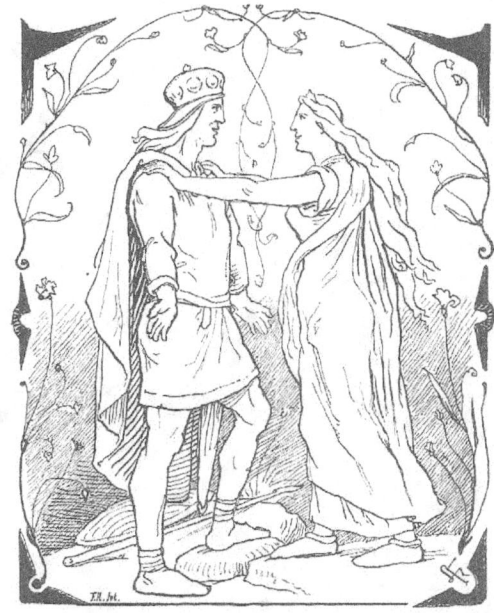

Svipdagr is reunited with Menglöð as described in *Fjölsvinnsmál*.

THOR'S HAMMER.

It was away down in the underground caves, and beneath the roaring waters of the rivers, and deep in the hearts of the mountains that these elfins workmen dwelt, and worked their smithies, and spun their gold and brass.

"Make me a crown of gold for Sif the wife of Thor," snarled Loke, bursting in upon the workshop of the elves.

The goddess Sif holds her long, golden hair while grain grows behind her in an illustration from 1897

Sif --John Charles Dollman--1909

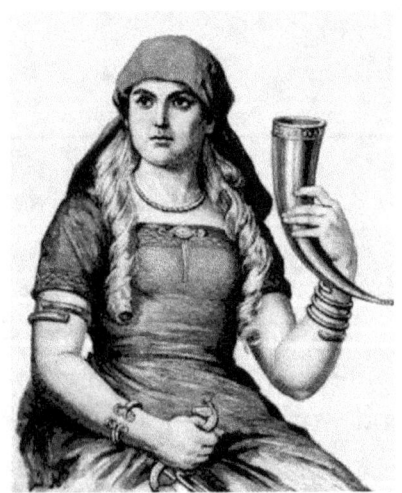

Sif --Jenny Nyström--1893

The elves hearts were malicious and sometimes cruel, but they were the willing and ready workers of the gods; and so, at even this ill-natured command from Loke, they set themselves to work.

Loki with a fishing net (per Reginsmál) as depicted on an 18th-century Icelandic manuscript (SÁM 66)

The coals burned and blazed; the forges puffed and blew; the little workmen moulded and turned and spun their gold. Hardly had the Sun-god lifted his head above the castles of the frost *ettins*, hardly had his light fallen upon the rich colors of the rainbow bridge, when Loke came forth from the underground caves, the shining crown in his hand.

Quickly he rose high in the air and stood before the gates of the city.

"Have you brought the crown?" thundered Thor from within the gates.

"I have brought the crown," answered Loke in triumph. "And more than that," added he, when the gates had been opened to him, "I have brought as gifts from the elves, a ship that will sail on land or sea and a spear that never fails. O there are no such workmen among any elfins as these who made the spear, the ship and the crown."

"You boast of what you do not know," croaked Brok, a little fay who stood near by.

"Who says I do not know?" cried Loke, turning sharply.

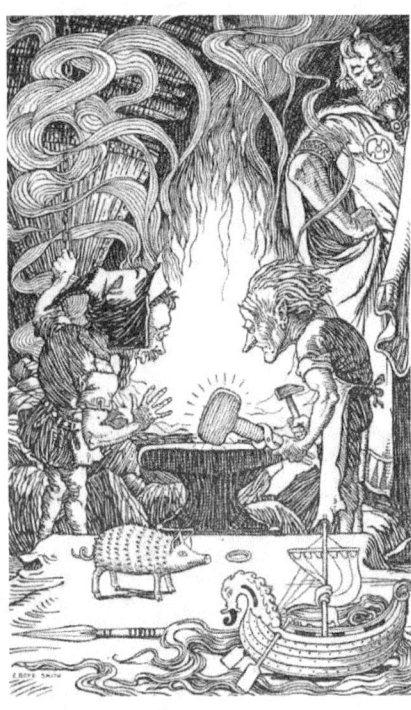

Brokkr forging Mjöllnir (hammer of Thor)

"I say you do not know," croaked the little elf again, his eyes snapping angrily, his whole frame quivering with rage. "I have a brother, a workman in brass and gold, who can make gifts more pleasing to the gods than any you have brought."

Loke looked down upon the little fay in scorn. "Go to your brother," he sneered, "and bring to us the wonderful things you think he can make. Bring us one gift more wonderful than these I have, or more acceptable to Odin and Thor, and I will give your brother my head to pay him for his efforts." Then Loke roared with laughter, believing that he had made a rare, rich joke.

Hardly had the roars of laughter died away, when Brok, gliding down the rainbow bridge with a swiftness equalled only by the lightning, sprang into Midgard, and was making his way towards the great mountain, beneath which worked the forges of his brother, the master-workman—Sindre.

"Someone cometh," said the elves, pausing in their work to listen, their busy hammers in mid-air.

"Fear not," answered Brok, his harsh voice echoing down the great halls. "It is I—Brok—and I come to demand of you that now, if never again, you do your best; for Loke boasts to the gods of Asgard that no elves in all the caverns of the under-world can make one gift more wonderful or more acceptable to Odin than those he brings—a crown of gold, a ship that will sail on land or sea, and a spear that never fails!"

A terrible roar burst forth from the hosts of angry elves. "We will see! We will see!" they thundered. And seizing their hammers they set to work. The great forges blazed. The sparks

flew. The smoke poured forth from the mountain top. Loke, looking out from the shining city, trembled. Well did he know the workmanship of these elves of Brok; and well did he know how rash had been his scornful promise to the angry little fay.

"We will make a hammer for Thor," said Sindre, the greatest among the workmen in this under world; "a hammer, that when thrown from his mighty hand, shall ring through all the heavens. A trail of fire shall follow it. Its aim shall never fail; and it shall carry death and destruction wherever it falls.

"Blow thou the bellows, Brok; and I myself will mould the hammer from the red hot iron."

With Brok at the bellows, the very mountain rocked, and Midgard for miles about was ablaze with the blaze of light from the mountain top.

"This shall not be," snarled Loke. And rushing down from Asgard he crouched outside the great, black cave to listen.

"A hammer for Thor!" Those were the words he heard. The angry face grew more vexed. An instant, and there was no Loke at the cavern mouth; but instead, a poisonous, stinging gadfly, whose green back glistened, and whose shining wings buzzed and hummed with cruelty and revenge. There was a hard, ringing tone of defiance in their singing, and the tone was like that of the voice of Loke himself.

"You shall drop the bellows," buzzed the gadfly bitterly, as it alighted upon the neck of Brok.

It was a cruel sting; and its poison forced, even from the sturdy Brok, a cry of pain.

"I know you. It is Loke," he cried; "but I will not drop the bellows though you sting me through and through and with a thousand stings!"

The gadfly buzzed with rage. Straight towards the hand upon the bellows it darted. Brok groaned again. His face grew pale; he quivered with the pain; still he held the mighty bellows and worked the roaring forge.

"You will not!" hissed the gadfly; and again it drove its poison sting, this time straight between the eyes of the suffering elf. And now Brok staggered. His hands relaxed their hold. Blinded with pain, he dropped the bellows. The blood ran down his face. The gadfly still hummed and buzzed.

"You have nearly spoiled it," cried Sindre. "Why did you drop the bellows? See how short the handle is! And how rough! But it cannot be helped now; nor will its terror be any less to Loke. Ha, ha, I would have made it handsome; but there is a power in it that shall make even the gods tremble in all the ages to come. Hurry away with it, and place it in Thor's mighty hands. And

here are other gifts. Take them all, and bring me Loke's head. He has promised. Surely even he must keep his word, wicked and deceitful though he is."

Brok seized the hammer, and, with the gifts, hurried up through the dark cavern, out into the light of Midgard, up the rainbow bridge, and, with triumph in his swarthy face, sprang into the presence of the great god Odin.

Loke roared with laughter at the sight of the awkward, clumsy hammer; but there was a proud, confident look in the fay's eyes that Loke did not like; and, coward that he was, his heart began already to fail him.

"Let us see the gifts," said Odin, "that we may judge which workman among the elfins has proved himself most wonderful."

"First of all," said Loke, coming forward, "Here is the golden crown for Sif."

Sif, the wife of Thor, previously was lying asleep outside her house with her beautiful golden hair flowing and Loki took out his shears and he cut off her splendiferous hair.

Eagerly Thor seized the crown, and placed it upon poor Sif's head.

"Wonderful! wonderful!" cried all the gods, for straightway the golden hair began to grow to Sif's head, and in a second it was as if her golden locks had never been stolen from her.

"To you, O Odin," said the elf, now coming forward, "I give this ring of gold. It is a magic ring; and each night it will cast off from itself another ring, as pure and as heavy, as round and as large as itself."

"What is that," sneered Loke, "compared with this? See, O Father Odin, I bring you a magic spear. Accept this, my second gift. It is a magic spear that never fails."

"But behold my second gift," interrupted Brok. "It is a boar of wonderful strength. It, too, is magic. No horse can run, no bird can fly with such speed. It travels both on land and sea; and in the night its bristles shine with such a light, that it matters not how dense the blackness, the forest or the plain will be as bright as noonday."

"I, too, have a gift that will travel on land or sea," cried Loke, pushing himself forward again. "See, it is a ship. And not only will it travel on land or sea, but it can lift itself and sail like a bird above the clouds and through the air."

"It will be hard indeed to say which gift is greatest," said Odin kindly.

"Look now, O, Odin, and Frigg and Thor and Sif and all the gods, at this the last of my three gifts. This hammer, O Thor, I bring to you, the god of thunder. Strike with it, and your thunders shall echo and re-echo from cloud to cloud as never they were heard before. Thrown into the air or at a foe, like Loke's spear, it shall never miss its aim; but, more than that, it shall return

always to the hand of Thor. No foe can conceal it, no foe can destroy it. It will never fail thee, O Thor, thou god of thunder."

"But what a clumsy handle," sneered Loke, who already began to fear the hammer was to win the favor of the gods.

"Yes," answered Brok, "the handle is clumsy and it is short. But none knows better than you why it is so."

Loke colored and moved uneasily. "Do not think," continued Brok, "that I do not know it was you who sent the poisonous gadfly to sting and bite me as I worked at the blazing forge, pounding out the brass and gold from which this hammer is made.

"You thought to pain me into giving up this contest, you coward! you evil one! you boaster!

"When the handle was welded just so far, you drove the gadfly into my eye. I could not see to finish the work; but although the handle is short and clumsy, the magic power is there, and with it in his hand, no power in earth or among the frost giants even can overcome our great god Thor."

A ringing shout of joy arose from the gods. Thor swung his hammer over his head and threw it far out against the clouds. The thunder rolled, the clouds filled with blackness, and the lightnings flashed, as the magic hammer, humming through the air, came back to the hands of Thor.

"Now give me my wager," cried Brok. "I was promised the head of Loke."

"Take it," laughed Loke. "Take it."

Brok drew near. "I will take it," he hissed through his set teeth; "and a rich day will it be both in Midgard and in Asgard when your miserable head is bound down in the home of the elves of the underground world."

"But halt," commanded Loke. "My head you may have; but you must not touch my neck. One drop of blood from that, and you forfeit your life."

Brok stood for a moment white with anger. He knew that he was foiled. Then springing forward, he thundered, "I may not touch your neck; but see, I have my revenge." And so, falling upon Loke, who struggled, but struggled in vain, he whipped from his mantle a thong and thread of brass; and before even Loke knew what had been done, he had sewed, firm together, the lying boasting lips of the evil god, Loke, the wicked-hearted son of Odin.

Wolfgang Ortmann--1930

Thor's Wonderful Journey

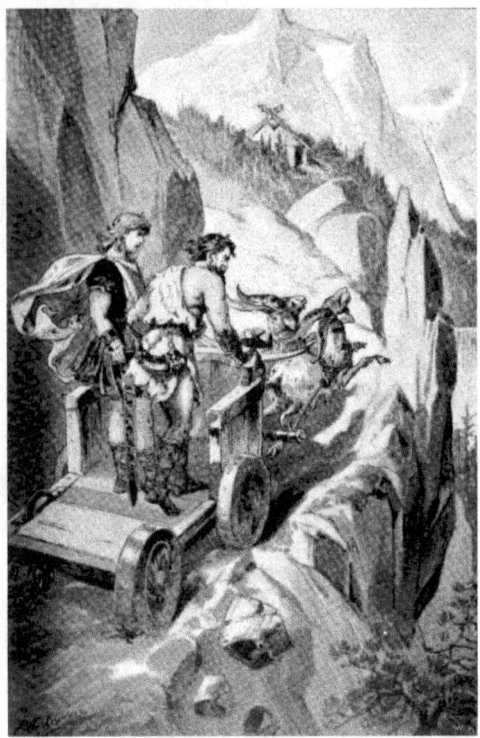

Thor and Tyr on the way to Hymir's

I.

ONE morning Thor asked Loki, the fire-god, if he would like to go forth with him to Utgard, the stronghold of the giants, where he was going to try, with his mighty hammer, to conquer those fierce enemies of Asgard. Loki was glad to go with him, and the two gods started forth in Thor's chariot, drawn by two goats.

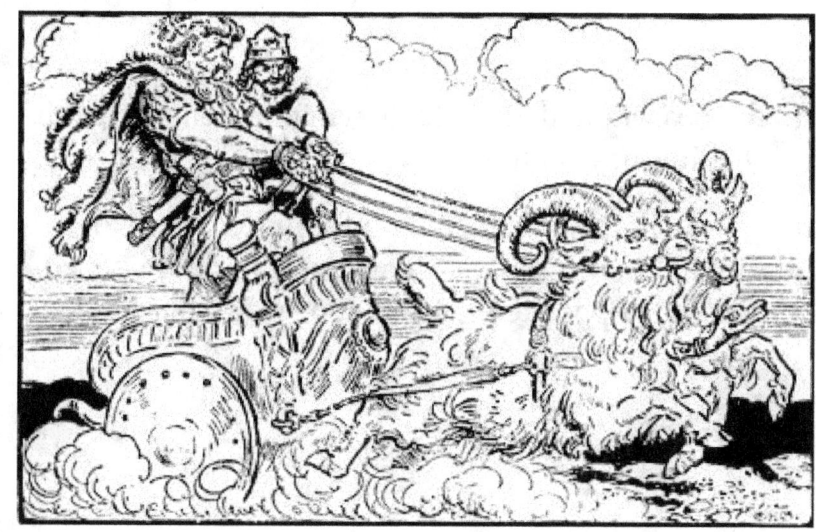

Thor often went on a journey, so the dwellers in Asgard did not wonder to see him getting ready for a long drive. As Thor and Loki drove along, the heavy chariot rattled, and made the thunder echo among the hills. People in our world, down below in Midgard, heard the rumbling, and said: "What a heavy thunderstorm! How the thunder crashes and rumbles!"

Toward evening the travelers stopped at a peasant's hut, and Thor, alighting from his chariot, went to the door of the house, to ask shelter for the night.

"I will gladly give you a room, but I have no food in the house," said the man who opened the door.

"Oh, never mind that," said Thor; "I will provide the food." So Thor and Loki stopped for the night at the peasant's hut. They found the family within, the man, his wife, and two children, a boy and a girl. All looked on in great surprise to see Thor kill his two goats and cook them for the evening meal. "Eat all you wish of the meat," said Thor, "but be careful not to break any of the bones; throw them all into the two skins which I have spread upon the floor."

Now the boy, whose name was Thialfe, wondered why Thor should say this, and as he happened to have a piece of the leg-bone, he thought there could be no harm in breaking it open, to get out the soft marrow to eat. Thor was just then talking to Loki, and did not notice what had been done; but next morning the boy learned a lesson that he never forgot.

When Thor was ready to start off again, next day, he held his magic hammer over the skins in which lay the bones. All at once the goats became whole again, and stood there just the same as before, except that one of them limped with his hind leg.

Then the young Thialfe knew why Thor had told them not to break the bones. At first, when he saw Thor's angry face, and how he grasped his hammer, the boy was frightened, and wanted to run away; but soon he remembered it would be cowardly to do that, so he went to Thor, and asked his forgiveness. Now the mighty thunder-god, though often angry, was always just and kind. After scolding the boy as he deserved, he freely forgave him, and said that he and his sister might go along with Loki and himself on their journey.

II.

The four started off, after saying good-by to the peasant and his wife, leaving in their charge the chariot and goats, for it seemed best to finish the journey on foot.

At nightfall they entered a thick forest, through which they wandered on for miles, when all at once they came upon a house, and a strange-looking house it was. The wide front door opened into a big room; at the left was a small room, and just opposite the front door were four long, narrow rooms.

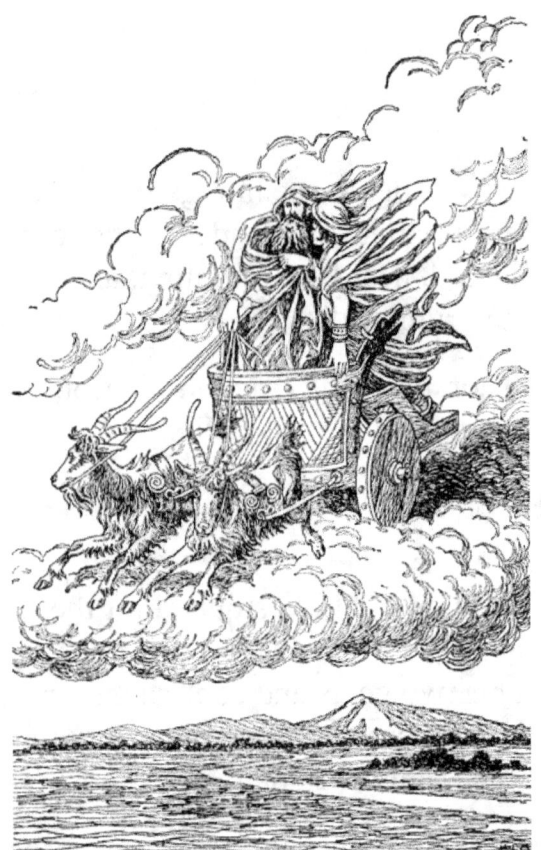

THOR AND LOKI IN THE CHARIOT.

The travelers wondered to find a house in the depths of a forest, but they were glad to have shelter for the night, and all lay down for a good rest. Soon after midnight they were awakened by groans and strange sounds, and the earth began to tremble. Thor sent his companions into the farthest room, grasped his hammer, and stood on guard by the door. At daybreak he started forth to find out what had caused the noise. He had not gone far when he came upon a huge jötunn, lying on the ground asleep, and Thor found that he was making the earth tremble with his snoring, which must have been the sound they had heard in the night.

While Thor was looking at the jötunn, he awoke, and spoke to the god. "Ho, ho! I think you little fellow must be Thor, of whom I have often heard, but really, I did not think you were quite so small! Now the sun is up, and I must be off; but where is my other glove? Oh, here it is, on the ground!" And the giant stooped and picked up his glove, which was the very house in which

our four travelers had spent the night, with the big front door where the hand went in, the thumb for the one side-room, and the four narrow finger-rooms opposite the door.

"If you are going my way, you may come along with me," said the giant. So they journeyed together for one day, but even mighty Thor could hardly keep up with the giant's long strides.

When night came, the jötunn stopped under a large oak tree, and said, "I am going to sleep; you may eat your supper, if you wish; here is a bag full of things." Saying this, he fell asleep, and was soon snoring. But when Thor tried to open the bag of food, he could not untie the cord. This made him angry, for the giant had tied up their food with his own. He looked at the huge figure lying before him asleep, and when he thought what a mean trick the giant had played upon them, Thor seized the magic hammer, and threw it at him.

"Did a leaf fall on me?" said the giant, sleepily. "Haven't you eaten your supper yet? Well, I am going to sleep again." And soon he was snoring louder than before. Thor grasped his hammer tighter than ever, and threw it with such strength that it seemed as though it must surely have killed the giant; but again he rubbed his eyes, and said, "I thought an acorn fell on my head!" He had hardly spoken when he was asleep again.

Then a third time Thor hurled his hammer with all his strength, and it seemed to hit his enemy in the forehead, and was buried out of sight, but the jötunn only said: "I think there must be birds overhead in this tree; I thought a feather dropped down on me. Are you awake, Thor? I think we'd better be going on with our journey, and if you are bound to go to Utgard, I will show you the way, but I advise you to go home instead; you will find bigger fellows than I in Utgard!"

But Thor had made up his mind to go on, and nothing could make him change. At noontime the four friends left their giant guide, whose path led another way. They had not traveled far when Thor spied a large city looming up before them, and soon they came to Utgard, the home of the fierce giants.

Although it was surrounded by high walls, Thor and his friends were able to creep through the bars of the great gate. When they came to the palace and found its door open, they went in, and there sat all the giants with their king, Utgard-Loki, at their head. A quite different Loki was this giant king from the mischievous fire-god, the Loki from Asgard, who now stood before him.

III.

Upon seeing the four strangers, the king of the giants said: "Why, this must be the god Thor. I really did not suppose that you were such a little fellow, Thor! but probably you are stronger than you look. Now, before you sit down at our table, you must each show some proof of your strength!"

Then Loki, who was very hungry, said he was sure he could eat more than anyone else; so the king called one of the giants to come forth, saying to Loki, "If you can indeed eat more than one of my men, you will perform a great feat."

A huge trough, full of meat, was brought in, and Loki began eating at one end, while the jötunn began at the other. They reached the center together; but Loki had eaten only the meat, while the giant had devoured meat, bones, trough, and all.

Thialfe, the peasant boy, took his turn next, and boasted that he was the fastest runner of them all. "Oh," said the king, "it will be a most wonderful feat if you can win a race against one of my men!" The first time Thialfe ran the course he kept ahead until near the end, and was beaten by only a few yards. The second time he came off worse, and the third time he was only halfway around when the giant had reached the goal.

Thor, however, was not at all cast down by the failure of the others, and he proposed to try a drinking match. So the king brought forth a long drinking horn, saying, "My men usually empty this in one draught, if they are very thirsty, though sometimes they have to take it in two swallows, or even three."

Then Thor put his lips to the drinking horn, and took one long, deep pull, thinking he had surely emptied it, but to his surprise, the water had lowered only a few inches. Again he lifted the horn, feeling sure he should empty it this time, yet he did no better than before. The king said, "You have left a great deal for your last drink!"

This made Thor try his very best; but it was of no use, he could not empty the horn.

"So you are not as strong as you seemed, after all! Do you care to try anything else?" said the king of the giants, in a mocking tone.

"Oh, certainly, anything you like!" replied Thor.

"Well," said the king, "I will give you something easy this time, since I see you are not as strong as I expected. You may try to lift this cat from the floor; it would be mere child's play for one of my men."

Thor put out his hand to lift the cat, but he could raise only one paw, though he used all his strength.

"Well, it is no more than I expected!" said the king; "you boast of your strength, but you do not show it to us."

By this time Thor was getting very angry, and he spoke fiercely, "I will challenge any one of you to fight with me!"

The king looked about the hall to find someone small enough to wrestle with Thor. Then he said, "All my men are too large, I shall have to send for one of the women!" Soon a bent old woman came hobbling in, and Thor thought it would be nothing to overcome her; but the longer

they wrestled, the stronger the old woman became, and at last, when it was plain that she was going to win, and Thor had been thrown down upon the floor, the king called to them to stop.

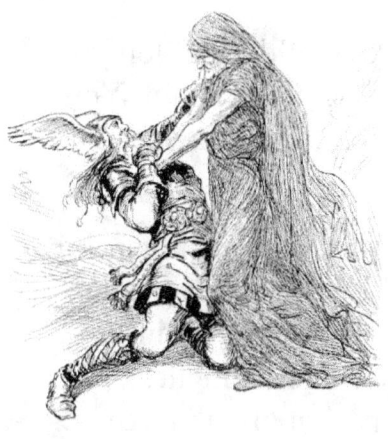

Thor wrestled with Elli

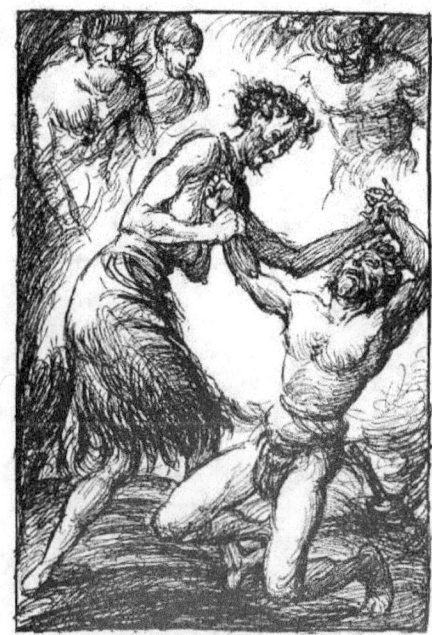

A depiction of Elli wrestling Thor--Robert Engels--1919

Thor and his friends were then invited to sit down at the feast, and the next morning, after a good breakfast, they started on their journey homeward. Utgard-Loki, the jötunn king, went

with them to the city gate, and when he was about to leave them, said, "Do you find it as easy as you expected to overthrow the giants?"

"No," said Thor, who was too honest to hide his shame, "I am vexed that I have done so little, and I know that after this failure, you will all laugh at my weakness."

"No, indeed," replied the king; "since you are now well outside our stronghold I will tell you the truth about what you saw there, and I will take good care not to let you get in again. You have greatly surprised us all, for we did not dream that you were so strong, and I have had to use magic to hold out against you.

"When you met the first giant in the forest you would have killed him with your hammer, if he had not put a mountain between himself and you. Loki was a wonderful eater, but we matched him against fire, and who can devour more than fire? The boy was a swift runner, and I had to make him race against thought, in order to beat him; what can be swifter than thought? The horn, from which you drank, was the ocean, and you took such a mighty draught, that the people in Midgard saw the tide ebb. It was really not a cat you tried to lift, but the Midgard Serpent, and you pulled him so far that we feared he would let go his hold. Then you wrestled with Old Age, and who is there that can overcome Old Age?"

With these words the giant king vanished, and Thor, upon looking around, saw the city of Utgard was also gone.

Then silently, but with many thoughts of these strange things, Thor and Loki, with the boy and the girl, made their way back to Asgard.

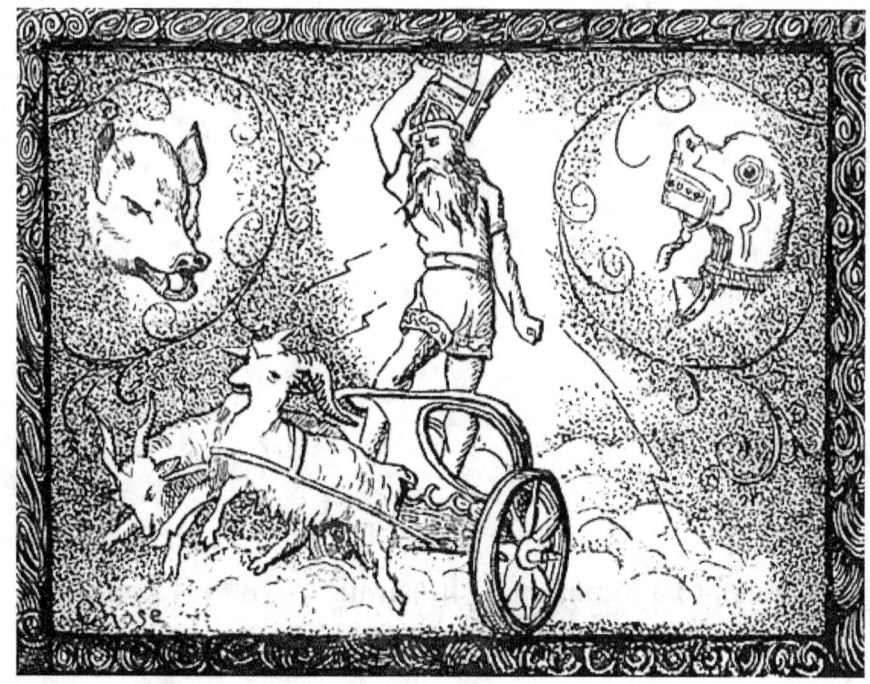

How Thor lost his Hammer

"Come, Loki, are you ready? My goats are eager to be off!" cried Thor, as he sprang into his chariot, and away they went, thundering over the hills. All day long they journeyed, and at night they lay down to rest by the side of a brook.

When Baldur, the bright sun-god, awoke them in the morning, the first thing Thor did was to reach out for Miölnir, his magic hammer, which he had carefully laid by his side the night before.

"Why, Loki!" cried he. "Alas, my hammer is gone! Those evil frost giants must have stolen it from me while I slept. How shall we hold Asgard against them without my hammer? They will surely take our stronghold!"

"We must go quickly and find it!" replied Loki. "Let us ask Freyja to lend us her falcon garment."

Now the goddess, Freyja, had a wonderful garment made of falcon feathers, and whoever wore it looked just like a bird. As you may suppose, this was sometimes a very useful thing. So Thor and Loki went quickly back to Asgard, and drove with all speed to Freyja's palace, where they found her sitting among her maidens. "Asgard is in great danger!" said Thor, "and we have come to you, fair goddess, to ask if you will lend us your falcon garment, for my hammer has been carried off, and we must go in search of it."

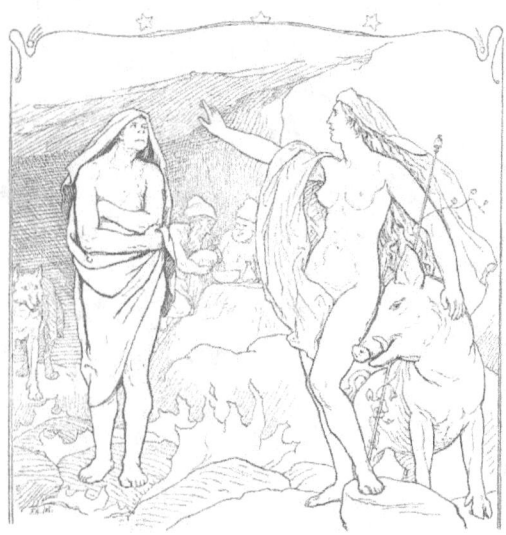

Nuzzled by her boar Hildisvíni, Freyja gestures to a jötunn in an illustration--1895--Lorenz Frølich

"Surely," answered Freyja, "I would lend you my falcon cloak, even if it were made of gold and silver!"

Then Loki quickly dressed himself in Freyja's garment and flew away to the land of the frost giants, where he found their king making collars of gold for his dogs, and combing his horses. As Loki came near, he looked up and said, "Ah, Loki, how fare the mighty gods in Asgard?"

"The Æsir are in great trouble," replied Loki, "and I am sent to fetch the hammer of Thor."

"And do you think I am going to be foolish enough to give it back to you, after I have had all the trouble of getting it into my power?" said the king. "I have buried it deep, deep, down in the earth, and there is only one way by which you can get it again. You must bring me the goddess Freyja to be my wife!"

Loki did not know what to say to this, for he felt sure that Freyja would never be willing to go away from Asgard to live among the fierce giants; but as he saw no chance of getting the hammer, he flew back to Asgard, to see what could be done.

Thor was anxiously looking out for him. "What news do you bring, Loki?" cried he. "Have you brought me my hammer again?"

"Alas, no!" said Loki. "I bring only a message from the giant king. He will not give up your hammer until you persuade Freyja to marry him!"

Then Thor and Loki went together to Freyja's palace, and the fair goddess greeted them kindly, but when she heard their errand, and found they wished her to marry the cruel jötunn, she was very angry, and said to Thor, "You should not have been so careless as to lose your hammer; it is all your own fault that it is gone, and I will never marry the giant to help you get it again."

Thor then went to tell Father Odin, who called a meeting of all the Æsir, for it was a very serious matter they were to consider. If the king of the giants only knew the power of the mighty hammer, he might storm Asgard, and carry off the fair Freyja to be his bride.

So the Æsir met together in their great judgment hall, in the palace of Gladsheim; long and anxiously they talked over their peril, trying to find some plan for saving Asgard from these enemies. At last Heimdall, the faithful watchman of the rainbow bridge, proposed a plan.

"Let us dress Thor," said he, "in Freyja's robes, braid his hair, and let him wear Freyja's wonderful necklace, and a bridal veil!"

"No, indeed!" cried Thor, angrily, "you would all laugh at me in a woman's dress; I will do no such thing! We must find some other way." But when no other way could be found, at last Thor was persuaded to try Heimdall's plan, and the Æsir went to work to dress the mighty thunder-god like a bride. He was the tallest of them all, and, of course, he looked very queer to them in his woman's clothes, but he would be small enough beside a giant. Then they dressed Loki to look like the bride's waiting-maid, and the two set off for Utgard, the stronghold of the giants.

Thor & Loki--Carl Larsson--1893

When the giant king saw them coming he bade his servants make ready the wedding feast, and invited all his giant subjects to come and celebrate his marriage with the lovely goddess Freyja.

So the wedding party sat down to the feast, and Thor, who was always a good eater, ate one ox and eight salmon, and drank three casks of mead. The king watched him, greatly surprised to see a woman eat so much, and said:—

"Where hast thou seen Such a hungry bride!"

But the watchful Loki, who stood nearby, as the bride's waiting-maid, whispered in the king's ear, "Eight nights has Freyja fasted and would take no food, so anxious was she to be your bride!"

This pleased the jötunn, and he went toward Thor, saying he must kiss his fair bride, but when he lifted the bridal veil, such a gleam of light shot from Thor's eyes that the king started back, and asked why Freyja's eyes were so sharp.

Again Loki replied, "For eight nights the fair Freyja has not slept, so greatly did she long to reach here!" This again pleased the king, and he said, "Now let the hammer be brought and given to the bride, for the hour has come for our marriage!"

All this time Thor was so eager to get his treasure back that he could hardly keep still, and if it had not been for what the wily Loki said, he might have been found out too soon. But at last the precious hammer was brought and handed to the bride, as was always the custom at weddings; as soon as Thor grasped it in his hand, he threw off his woman's robes and stood out before the astonished giants.

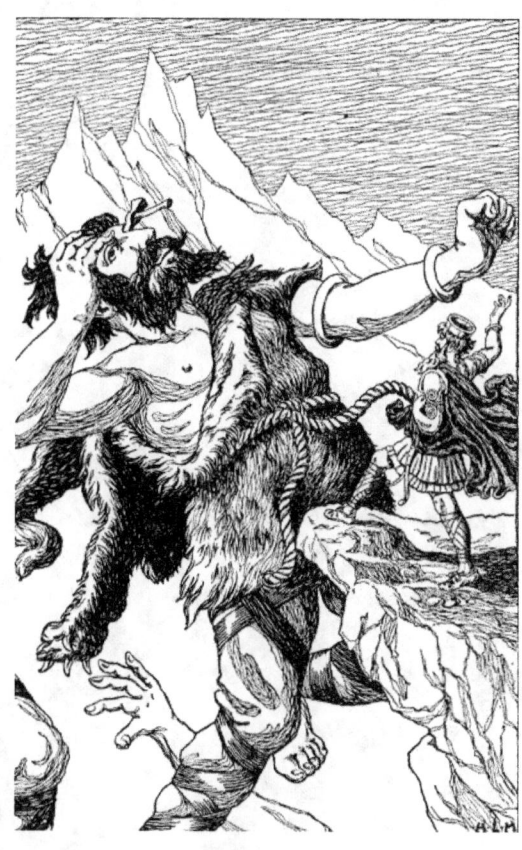

THOR'S BATTLE WITH THE FROST GIANTS.

Then did the mighty Thunderer sweep down his foes, and many of the cruel frost giants were slain. Once more the sacred city of Asgard was saved from danger, for Thor was its defender, and he was careful never again to let his magic hammer be taken from him.

Besides the hammer, Thor had two other precious things, his belt of strength, which doubled his power when he tightened it, and his iron glove, which he put on when he was going to throw the hammer.

"I am the god Thor, I am the War god, I am the Thunderer! Here in my Northland, My fastness and fortress, Reign I forever!

"Here amid icebergs Rule I the nations; This is my hammer, Miölnir the mighty; Giants and sorcerers Cannot withstand it!

"These are the gauntlets Wherewith I wield it, And hurl it afar off; This is my girdle, Whenever I brace it Strength is redoubled!"—LONGFELLOW

A Gift from Frigga

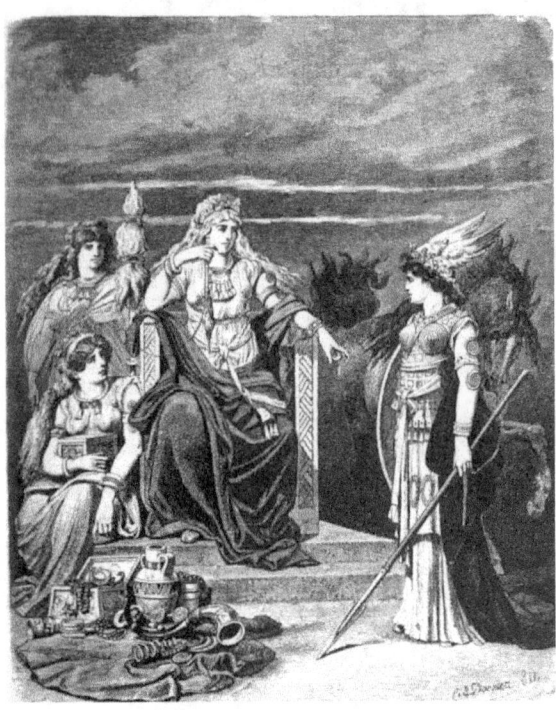

Frigg sits enthroned and facing the spear-wielding goddess Gná, flanked by two goddesses, one of whom (Fulla) carries her eski, a wooden box. Illustrated--1882--Carl Emil Doepler.

Frigg

Frigg is described as a goddess associated with foreknowledge and wisdom.

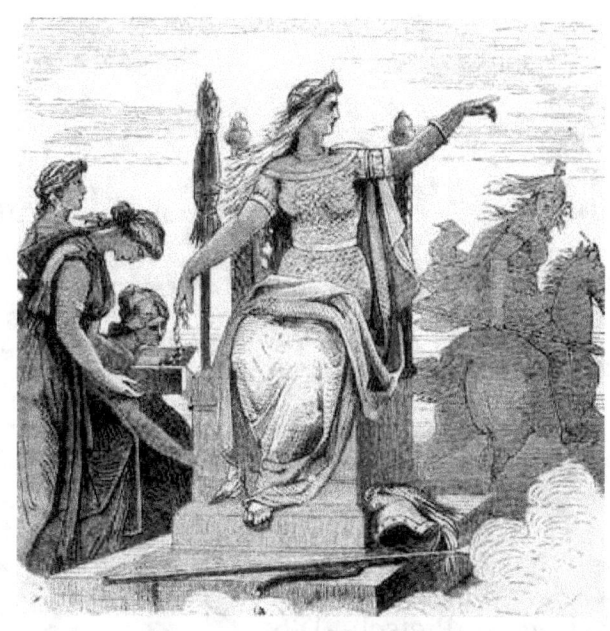

FRIGG ON HER THRONE, ARTIST UNKNOWN--1850

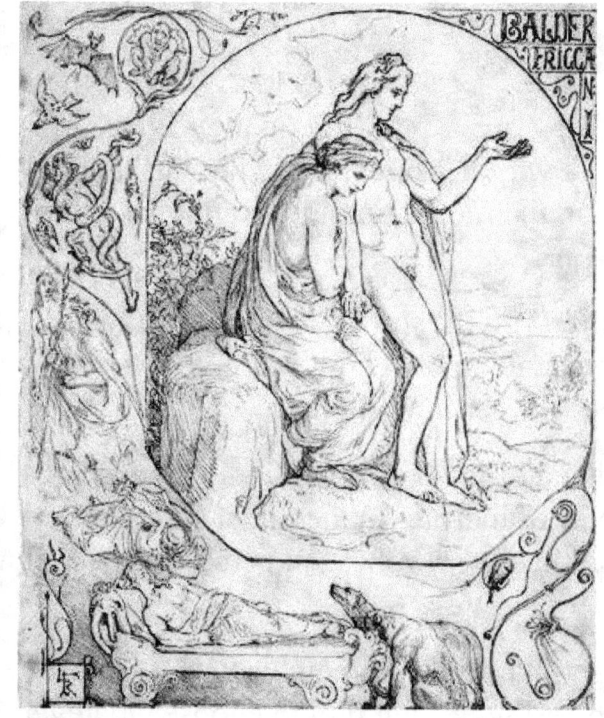

Frigg

A depiction of Fulla kneeling beside her mistress, Frigg--Ludwig Pietsch--1865

Long years ago there lived a peasant and his wife, who led a quiet, busy life on their little farm at the foot of a mountain. While the wife was busy indoors with her housework, her husband watched his flocks in the fields, or sometimes wandered up the mountain-side to hunt for game, which he would carry home for dinner.

One day he had strayed farther than usual, and found himself on the top of the mountain, where the ground was covered with ice and snow. All at once he came upon a high arched doorway opening into a great glacier, and he passed through to see whither it might lead.

The passageway widened out into a wonderful cavern, like a broad hall, sparkling with precious stones, and long, shining stalactites, that looked like icicles of marble. In the midst stood a beautiful goddess, surrounded by fair maidens, all dressed in silvery robes, and crowned with flowers.

The shepherd was so overcome by the wonder of this sight that he sank upon his knees. Then the goddess stretched forth her hands and gave him her blessing, telling him to choose whatever he wished, to carry home from the cavern. The man was no longer afraid when he heard her kind voice speaking to him, so he looked about, and at last humbly asked to have the pretty blue flowers which the fair one held in her hand.

The lovely goddess Frigga, or Holda, as the German people called her, smiled kindly, and told the poor shepherd he had made a wise choice. She gave him her bunch of blue flowers, with a measure of seed, saying to him, "You will live and be prosperous so long as the flowers do not fade."

The peasant bowed thankfully before the goddess, and when he rose she had vanished, and he was alone on the mountain-side, just as usual, with no cavern, no sparkling stones, and no fair maidens to be seen. If it had not been for the pretty blue flowers and the measure of seed in his hand, he would have thought it all a dream.

He hurried homeward to tell his wife, who was angry when she heard the story, for she thought he had made such a foolish choice. "How much better it would have been," said she, "if you had brought home some of those precious stones you tell about, which are worth money, instead of these good-for-nothing flowers!"

The poor man bore her angry words quietly, and made the best of what he had. He went to work at once to sow his seeds, which he found, to his surprise, were enough to plant several fields.

Every morning before he led his flock to pasture, and on his way home at night, he watched the little green shoots growing in his fields. Even his wife was pleased when she saw the lovely blue blossoms of the flax opening; then, after they had withered and fallen, the seeds formed. Sometimes it seemed to the good man, as he stood in the twilight looking over his field, that he saw a misty form, like the beautiful goddess, stretching out her hands over the field of flax, to give it her blessing.

When at length the seeds had ripened, Frigga came again to show the peasant how to gather his harvest of flax, and to teach his wife to spin and weave it into fine linen, which she bleached in the sun. The people came from far and near to buy the linen, and the peasant and his wife found themselves busy and happy, with money enough and to spare.

When they had lived many years, and were growing old among their children and grandchildren, the peasant noticed one day that the bunch of blue flowers, given to him so many years before, and which had always kept bright, were beginning to fade; then he knew he had not much longer to stay.

He climbed slowly up the mountain-side, and found the door of the cavern open. A second time he went in, and the kind goddess Frigga took the peasant by the hand, and led him away to stay with her, where she always took care of him.

Frigga was the queen of the gods, and she helped her husband, Odin, govern the world. It was her part to look after the children, and help the mothers take care of their families.

The Stealing of Iduna

I.

Odin, the wise father of the gods, started off one day on a journey through Midgard, the world of men, to see how his people were getting on, and to give them help. He took with him his brother Hönir, the light-giver, and Loki, the fire-god. Loki, you know, was always ready to go wherever he could have any fun or do any mischief.

Hœnir in an illustration from a 17th-century Icelandic manuscript

All the morning they went about among the homes of Midgard, and whenever Odin found busy, faithful workers, he was sure to leave behind some little thing which would hardly be noticed, a straw in the farmer's barn, or a kernel of grain in the furrow by the plow, or a bit of iron at the blacksmith's forge; but always happiness and plenty followed his little gift.

At noontime Loki was so hungry that he begged Odin to stop for dinner; so when they came to a shady spot by the bank of a river, the three gods chose it for their resting-place.

Odin threw himself down under a tree and began to read his little book of runes, or wise sayings, but Loki began to make a fire and get ready for the feast. Then he started off to a farmhouse nearby, leaving Hönir to cook the meat which they had brought.

As Loki came near the farmhouse, he thought to himself, "I will change myself into a cat, and then I can have a better chance to spy about." So he changed himself into a black cat, and jumping upon the kitchen window-sill, he saw the farmer's wife taking some cakes out of the oven. They smelled so good and looked so tempting that Loki said to himself, "What a prize those cakes would be for our dinner!"

Just then the woman turned back to the oven to get more cakes, and Loki snatched those which she had laid on the table. The good housewife soon missed her cakes; she looked all about, and could not think what had become of them, but just as she was taking the last lot from the oven, she turned quickly around, and saw the tail of a cat whisking out of the window.

"There!" cried she, "that wicked black cat has stolen my nice cakes. I will go after him with my broom!" But by the time she reached the door all she could see was a cow walking in her garden, and when she came there to drive her away, nothing was to be seen except a big raven and six little ones flying overhead.

Then the mischievous Loki went back to the river bank, where he had left his two friends, and showed them the six cakes, boasting of the good joke he had played upon the poor woman. But Odin did not think it was a joke. He scolded Loki for stealing, and said, "It is a shame for one of the Æsir to be a thief! Go back to the farmhouse, and put these three black stones on the kitchen table."

Loki knew that the stones meant something good for the poor woman, and he did not wish to go back to the house; but he had to do as the Allfather told him. As he went along he heard his friends the foxes, who put their heads out of their holes and laughed at his tricks, for the foxes thought Loki was the biggest thief of them all.

Changing himself into an owl, Loki flew in at the kitchen window, and dropped from his beak the three stones, which, when they fell upon the white table, seemed to be three black stains.

The next time the good woman came into her kitchen, she was surprised to find that the dinner was all cooked. And so the wonderful stones that Odin had sent brought good luck; the

housewife always found her food ready cooked, and all her jars and boxes filled with good things to eat, and never again was in need.

The other women all said she was the best housekeeper in the village, but one thing always troubled her, and that was the table with the three black stains. She scrubbed, and scrubbed, but could never make it white again.

Loki was very hungry by this time, and hoped that Hönir would have the meat nicely cooked when he came back to the river bank, but when they took it out of the kettle, they found it was not cooked at all. So Odin went on reading his book of runes, not thinking about food, while Hönir and Loki watched the fire, and at the end of an hour they looked again at the meat.

"Now, it will surely be done this time!" said Loki, but again they were disappointed, for the meat in the kettle was still raw. Then they began to look about to see what magic might be at work, and at last spied a big eagle sitting on a tree near the fire. All at once the bird spoke, and said, "If you will promise to give me all the meat I can eat, it shall be cooked in a few minutes."

The three friends agreed to this, and in a short time, as the bird had promised, the meat was well done, Loki was so hungry he could hardly wait to get it out of the kettle, but suddenly the eagle pounced down upon it, and seized more than half, which made Loki so angry that he took up a stick to beat the bird, and what do you think happened? Why, the stick, as soon as it touched the bird's back, stuck fast there, and Loki found he could not let go his end of it. Then away flew the eagle, carrying Loki with him, over the fields and over the tree-tops, until it seemed as though his arms would be torn from his body. He begged for mercy, but the bird flew on and on. At last Loki said, "I will give you anything you ask, if you will only let me go!"

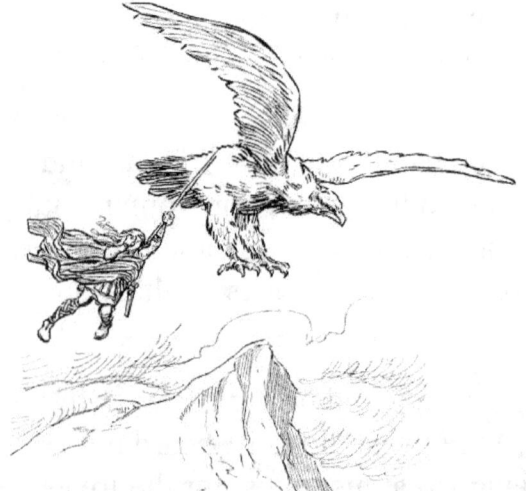

Now the eagle was really the cruel storm ettin Thiassi, and he said, "I will never let you go until you promise to get for me, from Asgard, the lovely goddess Iduna, and her precious apples!"

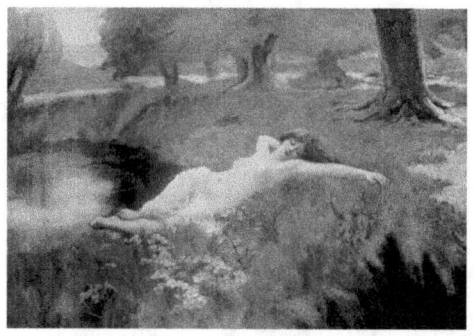

Idun by B.E. Ward

When Odin and Hönir saw Loki whisked off through the air, they knew that the eagle must be one of their giant enemies, so they hurried home to Asgard to defend their sacred city. Just as they came to Bifröst, the rainbow bridge, Loki joined them; but he took care not to tell them how the eagle came to let him go.

Odin felt sure that Loki had been doing something wrong, but knowing very well that Loki would not tell him the truth, he made up his mind not to ask any questions.

II.

The goddess Iduna, whom Loki was to tempt away out of Asgard, was the dearest of them all. She was the fair goddess of spring and of youth, and all the Æsir loved her. Her garden was the loveliest spot, with all sorts of bright, sweet flowers, birds singing by day and night, little chattering brooks under the great trees, and everything happy and fresh. The gods loved to go and sit with Iduna, and rest in her beautiful garden, within the walls of Asgard.

There was another delightful thing in the garden, and that was Iduna's casket. This was a magic box filled with big, golden-red apples, which she always gave her friends to taste. These wonderful apples were not only delicious to eat, but whoever tasted them, no matter how tired or feeble he might be, would feel young and strong again. So the dwellers in Asgard ate often of this wonderful fruit, which kept them fresh and young, fit to help the people in the world of Midgard. The casket in which Iduna kept her apples was always filled, for whenever she took out one, another came in its place; but no one knew where it came from, and only the goddess of youth, herself, could take the apples from the box, for if anyone else tried, the fruit grew smaller and smaller, as the hand came nearer, until at last it vanished away.

A few days after Loki's bargain with the giant Thiassi, Iduna was in her bright garden one morning, watering the flowers, when her husband, Bragi, came to say good-by to her, because he must go on a journey.

Bragi is shown with a harp and accompanied by his wife Iðunn in this 19th-century painting by Nils Blommér.

Loki watched him start off, and thought, "Now, here is my chance to tempt Iduna away from Asgard." After a while he went to the garden, and found the lovely goddess sitting among her flowers and birds. She looked up at Loki with such a sweet smile, as he came near, that he felt almost ashamed of his cruel plan; but he sat down on a grassy bank, and asked Iduna for one of her magic apples.

After tasting it, he smacked his lips, saying, "Do you know, fair Iduna, as I was coming home toward Asgard one day, I saw a tree full of apples which were really larger and more beautiful than yours; I do wish you would go with me and see them."

"Why, how can that be?" said Iduna, "for Father Odin has often told me that my apples were the largest and finest he ever saw. I should so like to see those others, and I think I will go with you now, to compare them with mine."

"Come on, then!" said Loki; "and you'd better take along your own apples, so that we can try them with the others."

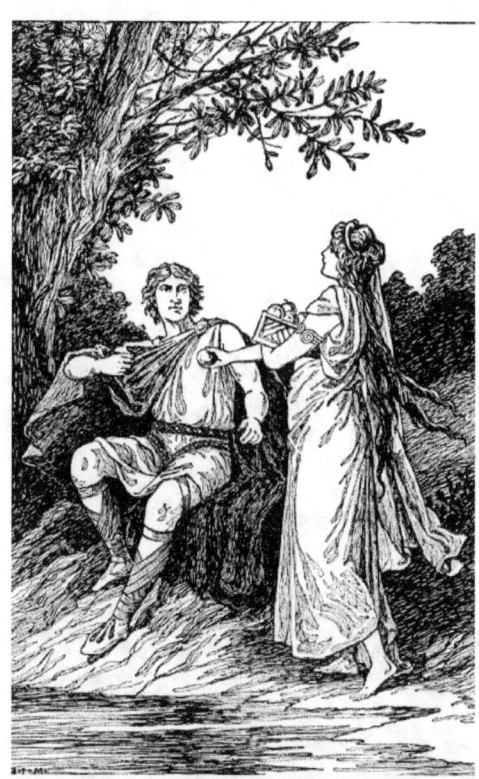
IDUNA GIVING LOKI THE APPLE.

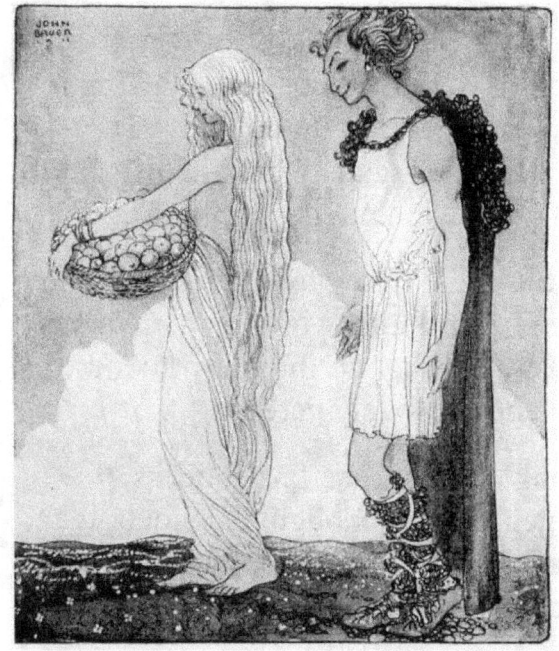
Loki and Idun--John Bauer--1911

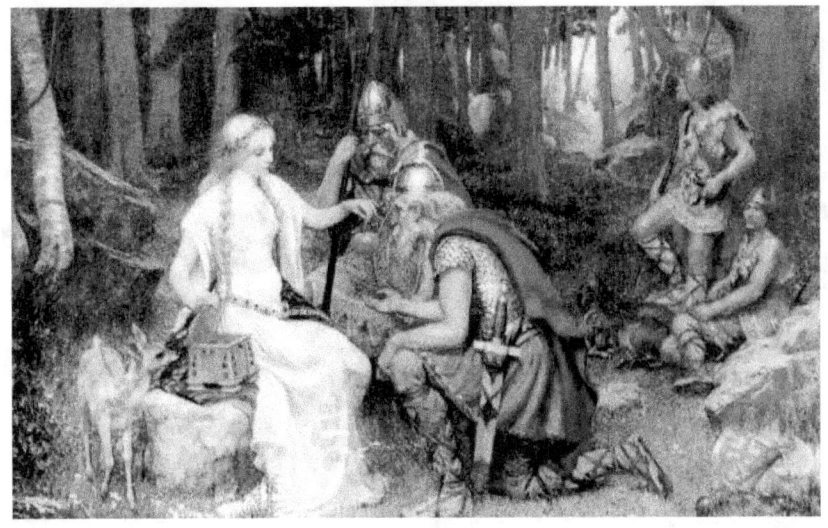

IDUN AND THE APPLES--J. DOYLE PENROSE--1890

Now Bragi had often told Iduna that she must never wander away from home, but, thinking it would do no harm to go such a little way, just this once, she took the casket of apples in her hand and went with Loki. They had hardly passed through the garden gate, when she began to wish herself back again, but Loki, taking her by the hand, hurried along to the rainbow bridge.

They had no sooner crossed over Bifröst than Iduna saw a big eagle flying toward them. Nearer and nearer he came, until at last he swooped down and seized poor Iduna with his sharp talons, and flew away with her to his cold, barren home. There she stayed shut up for many long dreary months, always longing to get back to Asgard, to see Bragi and her lovely garden.

The giant Thiassi had long been planning that if he could only once get the fair goddess of youth in his power, he would eat her magic apples, and so get strength enough to conquer the Æsir; but now, after all, she would not give him even one of them, and when he put his hand into the casket, the apples grew smaller and smaller, until at last they vanished, so that he could not get even a taste.

This cruel storm giant kept poor Iduna closely shut up in a little rock chamber, hoping that some day he could force her to give him what he wanted. All day long she heard the sea beating on the rocks below her gloomy cell, but she could not look out, for the only window was a narrow opening in the rock, high up above her head. She saw no one but the giant, and his serving-women, who waited upon her.

When these women first came to her, Iduna was surprised to see that they were not ugly or stern-looking, and, when she looked at their fair, smiling faces, she hoped they would be

friendly and pitiful to her in her trouble. She begged them to help her, and, with many tears, told them her sad story; but still they kept on smiling, and when they turned their backs, Iduna saw that they were hollow. These were the Ellewomen, who had no hearts, and so could never be sorry for any one. When one is in trouble, it is very hard to be with Ellewomen.

Every day the Ettin came to ask Iduna, in his terrible voice, if she had made up her mind to give him the apples. Iduna was frightened, but she always had courage enough to say "No," for she knew it would be false and cowardly to give to a wicked giant these precious gifts which were meant for the high gods. Although it was hard to be a prisoner, and to see no one but the cold, fair Ellewomen who kept on smiling at her tears, she knew it was far better to belong to the bright Æsir, even in prison, than to be a giant, or an Ellewoman, no matter how free or smiling they might be.

Idun and Thiassi--H. Theaker--1920

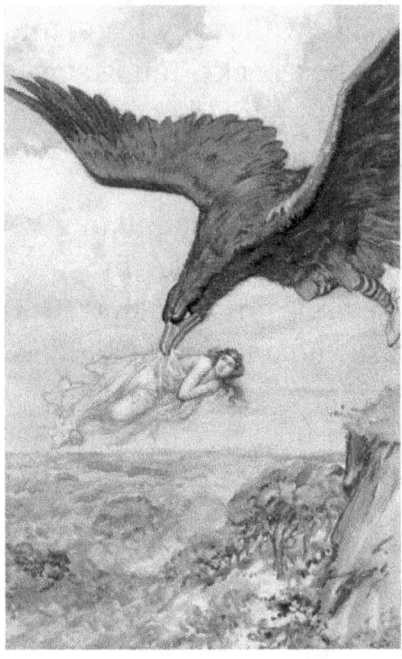

III.

All this while the dwellers in Asgard were sad and lonely without their dear Iduna. At first they went to her garden, as before, but they missed the bright goddess, and soon the garden itself grew dreary. The fresh green leaves turned brown and fell, the flowers faded, no new buds opened. No bird-songs were heard, and the saddest thing of all was that now the gods had no more of the wonderful apples to keep them fresh and strong, while two strangers, named Age and Pain, walked about the city of Asgard, and the Æsir felt themselves growing tired and feeble.

Every day they watched for Iduna's return; at last, when day after day had passed, and still she did not come, a meeting of all the gods and goddesses was called to talk over what they should do, and where they should search for their lost sister.

Loki, you may be sure, took care not to show himself at the meeting; but when it was found out that Iduna had last been seen walking with him, Bragi went after him, and brought him in before all the Æsir.

Then Father Odin, who sat on his high throne, looking very tired and sad, said: "Oh, Loki, what is this that you have done? You have broken your promise of brotherhood, and brought sorrow upon Asgard! Fail not to bring home again our sister, or else come not yourself within our gates!"

Loki knew well that this command must be obeyed, and besides, even he was beginning to wish for Iduna again; so, borrowing the cloak of falcon feathers which belonged to the goddess

Freyja, he put it on and set out for Utgard and the castle of the giant Thiassi, which was a gloomy cave in a high rock by the sea, and there he found poor Iduna shut up in prison.

By good luck, the giant was away fishing when Loki arrived, so he was able to fly in, without being seen, through the narrow opening in Iduna's rock cell. You would have taken him to be just a falcon bird, but Iduna knew it was really Loki, and was filled with joy to see him. Without stopping to talk, Loki quickly changed her into a nut, which he held fast in his falcon claws, and flew swiftly northward, over the sea, toward Asgard. He had not gone far when he heard a rushing noise behind them, and he knew it must be the eagle. Faster and faster flew the falcon with his precious nut; but the fierce eagle flew still faster after them.

Meanwhile, for five days, the dwellers in Asgard gathered together on the city walls, gazing southward, to watch for the coming of the birds, while Loki and Iduna, chased by Thiassi, the eagle, flew over the wide sea separating Utgard, the land of the giants, from Asgard. Each night the eagle was nearer his prey, and the watchers in the city were filled with fear lest he should overtake their friends.

At last they thought of a plan to help Iduna: gathering a great pile of wood by the city walls, they set fire to it. When Loki reached the place he flew safely through the thick smoke and flame, for you know he was the god of fire, and dropped down into the city with his little nut held fast in his falcon claws. But when the heavy eagle came rushing on after them, he could not rise above the heat of the fire, and, smothered by the smoke, fell down and was burned to death.

There was great joy in Asgard at having the dear Iduna back again; her friends gathered around her, and she invited them all into her garden, where the withered trees and flowers began to sprout and blossom; the gay birds came back, singing and building their nests, and the happy little brooks went dancing under the trees.

Iduna sat with Bragi among her friends, and they all feasted upon her golden apples; she was so thankful to be free, and at home in her garden again. Once more the Æsir became young and strong, and the two dark strangers went away, for happiness and peace had come back to Asgard.

Skaði(Skadi)

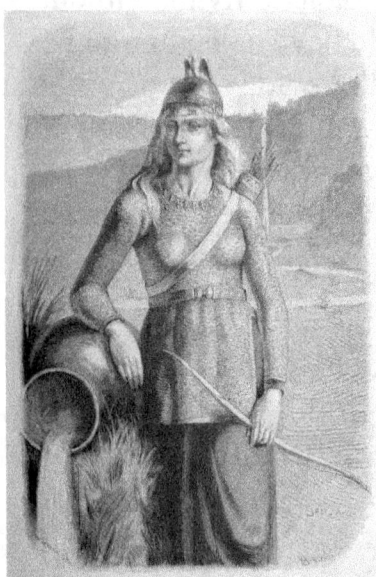

Skade--Carl Fredrik von Saltza--1893

While Iduna's friends were still crowding about her, all joyful and glad at getting her home again, they spied someone afar off, coming toward Asgard.

As the figure drew nearer, they saw it was Skadi, the tall daughter of the frost jötunn Thiassi, who had chased Iduna; she was dressed all in white fur, and carried a shining hunting-spear and arrows. Slung over her shoulder were snowshoes and skates, for Skadi had come from her mountain home in the icy north. Very angry about the loss of her father, she had come to ask the Æsir why they had been so cruel to him.

Father Odin spoke kindly to her, saying, "We will do honor to your father by putting his eyes in the sky, where they will always shine as two bright stars, and the people in Midgard will remember Thiassi whenever they look up at night and see the two twinkling lights. Besides this, we will also give you gold and silver." But Skadi, thinking money could never repay her for the loss of her father, was still angry.

Loki looked at her stern face, and he said to himself, "If we can only make Skadi laugh, she will be more ready to agree to the plan," and he began to think of some way to amuse her. Taking a long cord he tied it to a goat; it was an invisible cord, which no one could see, and Loki himself held the other end of it. Then he began to dance and caper about, and the goat had to do just what Loki did. It really was such a funny sight, that all the gods shouted with laughter, and even poor, sorrowful Skadi had to smile.

When the Æsir saw this, they proposed another plan: Skadi might choose one of the gods for her husband, but she must choose, from seeing only his bare feet. The giantess looked at them all, as they stood before her, and when she saw the bright face of Baldur, more beautiful than all the rest, she agreed to their plan, saying to herself, "It might be that I should choose him, and then I should surely be happy."

The gods then stood in a row behind a curtain, so that Skadi could see nothing but their bare feet. She looked carefully at them all, and at last chose the pair of feet which seemed to her the whitest, and of the finest shape, thinking those must be Baldur's; but when the curtain was taken away, she was surprised and sorry to find she had chosen Niörd, the god of the seashore.

The wedding took place at Asgard, and when the feasting was over, Skadi and Niörd went to dwell in his home by the sea. At first they were very happy, for Niörd was kind to his giant bride; but how could you expect one of the Æsir to live happily very long with a frost giantess for his wife?

Njörd's desire of the Sea--W. G. Collingwood--1908

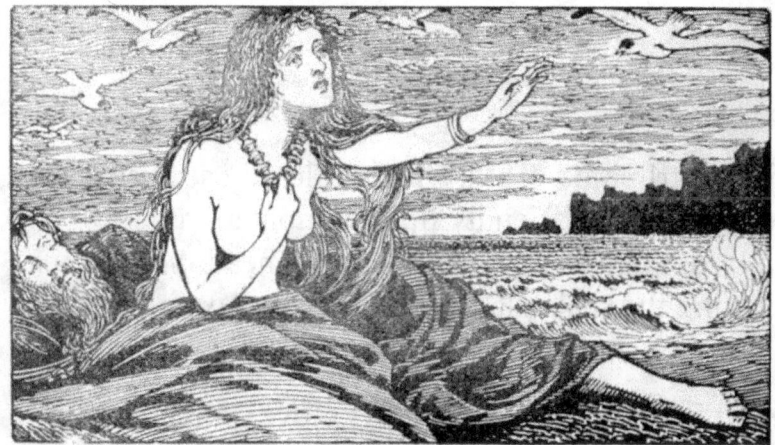

Skadi's longing for the Mountains--W. G. Collingwood--1908

Skadi did not like the roar of the waves, and hated the cries of the sea-gulls and the murmur of gentle summer winds. She longed for her frozen home, far away in the north, amid ice and snow.

And so they finally agreed that, for nine months of the year, Niörd should live with Skadi among her snowy mountains, where she found happiness in hunting over the white hills and valleys on her snowshoes, with her hunting dogs at her side, or skating on the ice-bound rivers and lakes. Then for the three short months of summer Skadi must live with Niörd in his palace by the sea, while he calmed the stormy ocean waves, and helped the busy fishermen to have good sailing for their boats.

SKADI HUNTING IN THE MOUNTAINS.

Niörd loved to wander along the shore, his jacket trimmed with a fringe of lovely seaweeds and his belt made of the prettiest shells on the beach, with the friendly little sandpipers running before him, and beautiful gulls and other sea birds sailing in the air above his head. Sometimes he loved to sit on the rocks by the shore, watching the seals play in the sunshine, or feeding the beautiful swans, his favorite birds.

There is a kind of sponge, which the people in the north still call Niörd's glove, in memory of this old Norse god.

Baldur

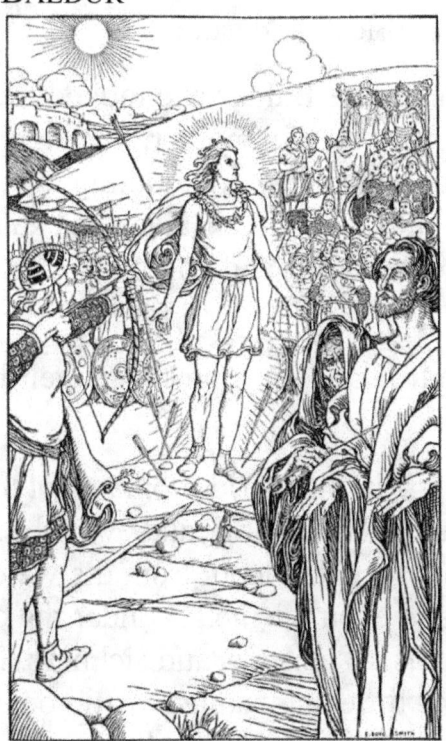

Each Arrow Overshot His Head--Elmer Boyd Smith (1902)

BALDUR was the best beloved of all the gods. Odin was their father and king; to him they turned for help and wise advice, but it was to Baldur they went for loving words and bright

smiles. The sight of his kind face was a joy to the Æsir, and to all the people of Midgard. They sometimes called him the god of light, a good name for him, because he truly gave to the world light and strength.

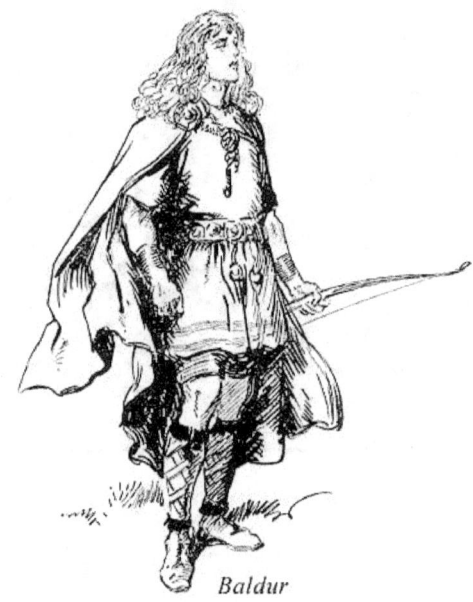
Baldur

Baldur was the son of Odin and Frigga; he was the most gentle and lovely of all the gods. His beautiful palace in Asgard was bright and spotless; no evil creature could enter there; no one who had wrong thoughts could stay in that palace of love and truth.

At last, after the bright summer was over, for many days Baldur had looked sad and troubled. Some of the Æsir saw it, but most of all, his loving, watchful mother, Frigga. Baldur could not bear to worry his mother, so he kept his sorrow to himself, saying nothing about it; but at last Frigga drew his secret from him, and then his friends knew that Baldur had had dreams which told of coming trouble, dreams of his leaving all his friends and going away from Asgard, to dwell in another land.

Odin and Frigga, fearing the dreams might come true and they must lose their beloved son, began to think what they could do to prevent it.

Then the loving mother said, "I will make all things in the world promise not to hurt our son." And so Queen Frigga sent out for everything in the whole world, and everything came trooping to Asgard, to her palace. All living creatures came from the land, from the water, and from the air. All plants and trees came; all rocks, stones, and even the metals under the earth, where the busy elves worked. Fire came, and water, as well as all poisons, and sickness. Everything promised not to harm the good Baldur, except one little plant called mistletoe, which was so small that Frigga did not send for it, feeling sure it could not do any harm.

"Now I am happy once more," said the queen, "for our Baldur is safe!" And she sat at peace in her beautiful palace, rejoicing that her dear son was free from all danger.

But Odin, the wise Allfather, still felt uneasy, even after all these promises, fearing what might happen. So he took his eight-footed steed, Sleipnir, and rode forth from Asgard to the

underworld to find Hela, the wise woman who ruled over that far-off land. She could tell everything that was going to happen, and she knew the names of all those who were coming to dwell with her. Odin was the only one wise enough to speak with Hela, for no one else knew the words that would call her forth from her dwelling; but when Odin called, she came to answer.

"Tell me," said he, "for whom are you making ready this costly room?"

"We make ready for Baldur, the god of light," replied Hela.

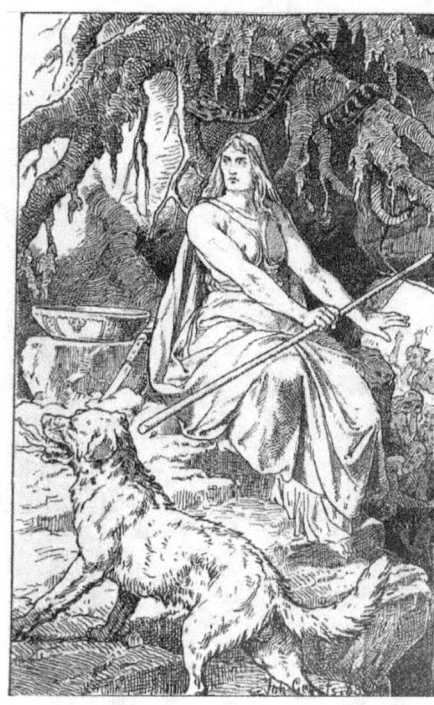

Hel--Johannes Gehrts--1889

"Who, then, will slay Baldur, and bring such darkness and sorrow to Asgard?"

Again said the wise woman, "It is Hodur, Baldur's twin brother, who will slay the sun-god." And with these words she vanished.

Sadly Father Odin returned to Asgard, and told his wife the words of Hela; but Frigga was not troubled in her heart, for she felt sure that nothing would hurt her dear son.

Loki tricks Höðr into shooting Baldr.

II.

One beautiful sunny day at the end of summer the gods had all gone out to an open field beyond Asgard to have some sports. As they all knew that nothing could hurt Baldur, they placed him at the end of the field for a target, and then took turns throwing their darts at him, just for the fun of seeing them fall off without hurting him. They thought this was showing great honor to Baldur, and he was pleased to join in the sport.

Loki happened to be away when they began to play, and when he came was angry in his heart that nothing could hurt Baldur.

"Why should he be so favored? I hate him!" said Loki to himself, and began at once to plan some evil.

All this while Queen Frigga sat in her palace, thinking of all her dear sons, and of how much good they did to men. As she sat thus, thinking, and spinning with her hands, there came a knock at the door. The queen called, "Come in!" and an old woman stood before her.

Frigga spoke kindly to her, and soon the old woman said she had passed by the field where the gods were playing, and throwing sharp weapons at Baldur.

"Oh, yes," said Frigga; "neither metal nor wood can hurt him, for all things in the world have given me their promise."

"What!" said the old woman; "do you mean that all things have really vowed to spare Baldur?"

"All," replied the queen, "except one little plant that grows on the eastern side of Asgard; it is called mistletoe, and I thought it too small and soft to do any harm."

Before long the old woman went away, and when she was quite out of sight of Frigga's palace, threw off her woman's clothes, and who do you suppose it was? Why, no woman at all, but that wicked Loki, of course, who hurried away out of Asgard, to find the poor little plant that did not know about Baldur's danger. When he came to the place where the plant grew, Loki cutting off a branch, quickly made a sharp arrow, which he carried back to the playground, where the Æsir were still at their game, all but one, Hodur, the god of darkness, Baldur's blind twin brother.

Then Loki went up to Hodur, and said to him in a low voice, "Why do you not join with the others in doing honor to Baldur?"

"I cannot see to take aim, you know, and besides, I have no weapon," said Hodur.

"Come, then, here is a fine new dart for you, and I will guide your hand," whispered wicked Loki; then he slipped the arrow of mistletoe wood into Hodur's hand and aimed it himself at Baldur, who stood there so bright and smiling.

Then poor blind Hodur heard a dreadful cry from all the gods: Baldur the Beautiful had fallen, struck by the arrow; he would now be taken away from them, to live with Hela in the underworld.

Every heart was filled with sorrow for this dreadful loss; but no one tried to punish him who had done the wicked deed, for they stood upon sacred ground, and the field was named the Peace-stead, or Place of Peace, where no one might hurt another. Besides, the gods did not know it was the false Loki who hated Baldur, that had struck him down.

When Frigga heard the sad news, she asked who would win her love by going to the underworld and begging Hela to let Baldur come back to them.

Hermod, the swift messenger-god, ready to do his mother's bidding, set forth at once on the long journey. Nine days and nights he traveled without resting, until he came to Hela's underworld. There he found Baldur, who was glad to see him, and sent messages to his friends in Asgard. Hela said Baldur might return to them on one condition: that every living creature, and everything in the world must weep for him.

So Hermod hastened back to Asgard, and when the Æsir heard Hela's answer, they sent out messengers over the world to bid all things weep for Baldur, their bright sun-god. Then did the beasts, the birds, the fishes, the flowers and trees, even stones and metals weep; as indeed we can see the teardrops come to all things when they are changed from heat to cold.

As the messengers were coming back to Asgard they met an old woman, whom they bade weep, but she replied, "Let Hela keep Baldur down below; why should I care?" When the Æsir heard of this, they thought it must have been the same old woman who went before to Frigga's palace, and we know who that was.

And so Baldur the beautiful, Baldur the bright, did not come back, and all the dwellers in Asgard were sad and sorrowful without him.

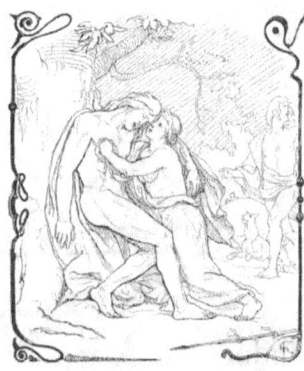

The Punishment of Loki

When Loki was driven out by the mighty Thor from Ægir's palace-hall he knew that he could never again be allowed to come among the gods in Asgard. Many times had this mischievous fire-god brought trouble and sorrow to the Æsir, but now he had done the most cruel deed of all, he had slain Baldur the Good, and had driven all light and joy from Asgard.

Far away he fled, among the mountains, hoping that no one would find him there; and near a lovely mountain stream he built for himself a hut with four doors looking north, east, south, and west, so that if the wise Allfather, on his high air throne in Asgard, should see him, and send messengers to punish him, the watchful Loki could see them coming and escape by the opposite door.

He spent most of the days and nights thinking how he could get away from the Æsir. "If I ran to the stream and turned myself into a fish," he thought, "I wonder if they could catch me. I could keep out of the way of a hook; but then there are nets; Ægir's wives have a wonderful thing like a net, for catching fish, and that would be far worse than a hook!"

When Loki thought of the net, he began to wonder how it was made, and the more he thought, the more he wished he could make one so as to see how a fish could keep from getting caught in it. He sat down by the fire in his little hut, took a piece of cord and began to make a fish-net. He had nearly finished it when, looking up through the open door, he saw three of the Æsir in the distance, coming toward his hut. Loki well knew that they were coming to catch him, and, quickly throwing his net into the fire, he ran to the stream, changed himself into a beautiful spotted salmon, and leaped into the water.

A moment later the three gods entered the hut, and one of them spied the fish-net burning in the fire. "See!" cried he, "Loki must have been making this net to catch fish; he always was a good fisherman, and now this is just what we want for catching him!"

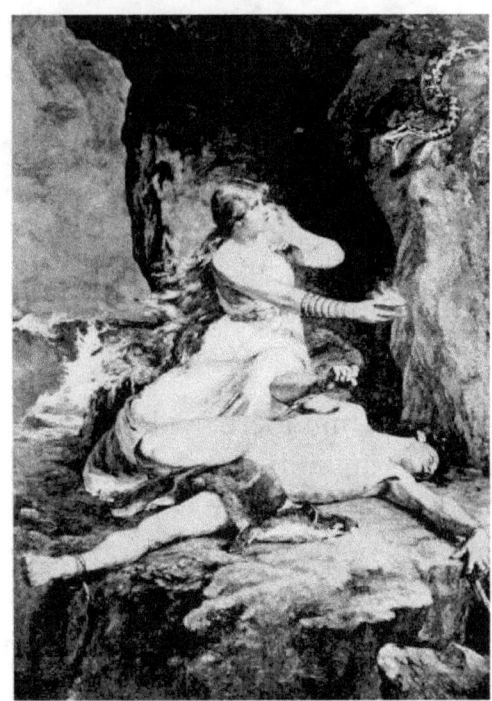

THE PUNISHMENT OF LOKI.

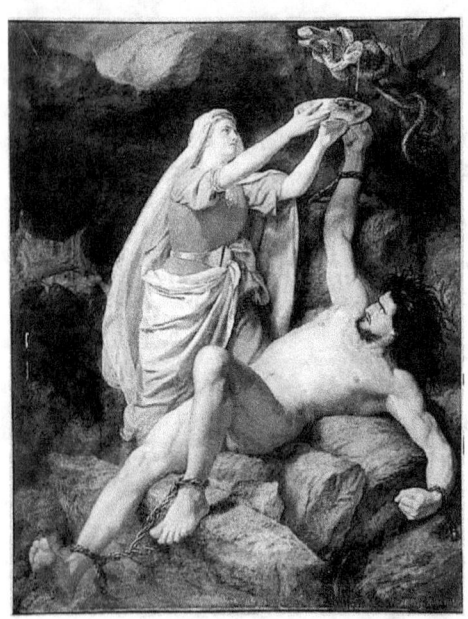

Loki and Sigyn--Mårten Eskil Winge--1863

So they snatched the last bit of the net from the fire, and by looking at it found out how to make another, which they took with them to the bank of the stream.

The first time the net was put into the water, Loki hid between two rocks, and the net was so light that it floated past him; but the next time it had a heavy stone weight, which made it sink down, till Loki saw he could not get away unless he could leap over the net. He did this, but

Thor, seeing him, waded out into the stream, where he threw the net again, so that Loki must jump a second time, or else go on out into the deep sea.

As he leaped, Thor stooped and caught him in his hand, but the fish was so slippery that Thor could hardly hold it. In the struggle the salmon's tail was pinched so tightly by the thunder-god's strong fingers that it was drawn out to a point, and the old stories say that is why salmon tails are so pointed ever since.

Thus was Loki caught in his own trap, and dreadful was his punishment. The Æsir chained him to a high rock, and placed a great, poisonous serpent, hanging over the cliff above his head.

If it had not been for Loki's good, faithful wife, he would have died of the poison that dropped from the snake's mouth. She watched by her husband, holding a cup above him to catch the poison. Only when she had to turn aside to empty the cup did the drops fall upon Loki; then they gave him such terrible pain that he shook the earth with his struggles, and the people in Midgard fled from the dreadful earthquake, in Iceland the great geysers, springs of hot water, burst through the earth, and in the south-lands burning ashes and lava poured down the mountain-sides.

There, chained to the cliff, the cruel, mischievous Loki was to lie until the Twilight of the gods, the dark day of Ragnarök, when all the mighty evil monsters and beasts would get free, and the terrible battle be fought between them and the gods of Asgard.

LOKE IN CHAINS.

From an Ancient Scandinavian Stone.

"Let him be bound even as the Fenris-wolf is bound!"

"Let him be bound with iron fetters!"

"Let him be nailed to the great rocks in the sea!"

"Let a poisonous serpent hang over him; and let the serpent drop, moment by moment, through all the time to come, his burning poison upon him! Let him lie there, chained and suffering till the last great day!"

"All this shall be," thundered Thor. Therefore, cruel, evil-hearted, peace-destroyer, unpropitious, Loke, suffered ages upon ages of punishment for his malice and his crime.

Ægir's Feast

Ægir, Rán and their nine daughters.
From a 19th century Swedish translation of the Poetic Edda.

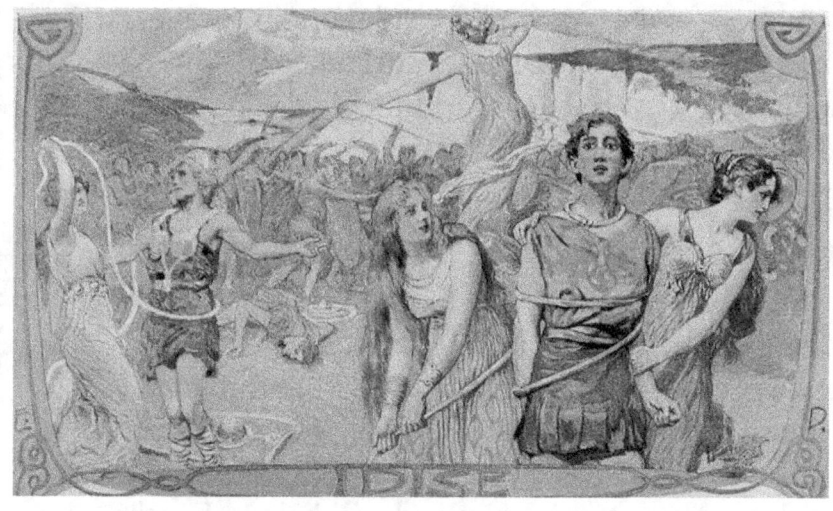

The Daughters Of Ran-- Hans Dahl

I.

ÆGIR was the ruler of the ocean, and his home was deep down below the tossing waves, where the water is calm and still. There was his beautiful palace, in the wonderful coral caves; its walls all hung with bright-colored seaweeds, and the floor of white, sparkling coral sand. Such wonderful sea-plants grew all about, and still more wonderful creatures, some, which you could not tell from flowers, waving their pretty fringes in the water; some sitting fastened to the rocks and catching their food without moving, like the sponges; others darting about and chasing each other.

"Deep in the wave is a coral grove, Where the purple mullet and goldfish rove; Where the sea-flower spreads its leaves of blue, That never are wet with falling dew, But in bright and changeful beauty shine Far down in the green and glassy brine. The floor is of sand, like the mountain drift, And the pearl-shells spangle the flinty snow; From coral rocks the sea-plants lift Their boughs where the tides and billows flow. The water is calm and still below, For the winds and waves are absent there, And the sands are bright as the stars that glow In the motionless fields of upper air."—PERCIVAL.

In that ocean home lived the lovely mermaids, who sometimes came up above the waves to sit on the rocks and comb their long golden hair in the sunshine. They had heads and bodies like beautiful maidens, with fish-tails instead of feet.

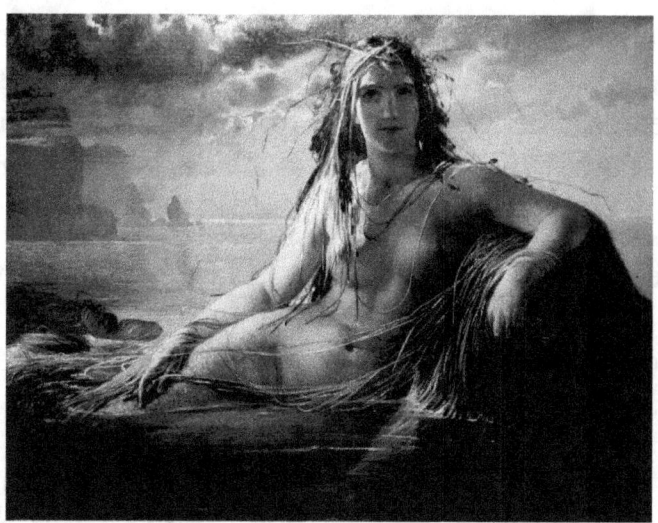

Dansk: Havfrue (Glyptoteket)-- Elisabeth Jerichau Baumann--1873

One day the gods in Asgard gave a feast, and Ægir was invited. He could not often leave home to visit Asgard, for he was always very busy with the ocean winds and tides and storms; but calling his daughters, the waves, he bade them keep the ocean quiet while he was away, and look after the ships at sea.

Then Ægir went over Bifröst, the rainbow bridge, to Asgard, where they had such a gay party and such feasting that he was sorry when the time came to go home; but at last he said good-by to Father Odin and the rest of the Æsir. He thanked them all for the pleasure they had given him, saying, "If only I had a kettle that held enough mead for us all to drink, I would invite you to visit me."

Thor, who was always glad to hear about eating and drinking, said, "I know of a kettle a mile wide and a mile deep; I will fetch it for you!"

Then Ægir was pleased, and set a day for them all to come to his great feast.

So Thor took with him his brother, the brave Tyr, who knew best how to find the kettle; and together they started off in Thor's thunder chariot, drawn by goats, on their way to Utgard, the home of the giants.

When they reached that land of ice and snow, they soon found the house of Hymir, the giant who owned "Mile-deep," as the big kettle was called. The gods were glad to find that the giant was not at home, and his wife, who was more gentle than most of her people, asked them to come in and rest, advising them to be ready to run when they should hear the giant coming, and to hide behind a row of kettles which hung from a beam at the back end of the hall. "For," said she, "my husband may be very angry when he finds strangers here, and often the glance of his eye is so fierce that it kills!"

At first the mighty Thor and brave Tyr were not willing to hide like cowards; but at last they agreed to the plan, upon the good wife promising to call them out as soon as she had told her husband about them.

It was not long before they heard the heavy steps of Hymir, as he came striding into his icy home; and very lucky it was for Thor and Tyr that the giantess had told them to hide, for when the jötunn heard that two of the Æsir from Asgard were in his home, so fierce a flash shot from his eyes that it broke the beam from which the kettles hung, and they all fell broken on the floor except Mile-deep.

After a while the giant grew quiet, and at last even began to be polite to his guests. He had been unlucky at his fishing that day, so he had to kill three of his oxen for supper. Thor being hungry, as usual, made Hymir quite angry by eating two whole oxen, so that, when they rose from the table the giant said, "If you keep on eating as much at every meal, as you have to-night, Thor, you will have to find your own food."

"Very well," said Thor; "I will go fishing with you in the morning!"

II.

Next morning Thor set forth with the giant, and as they walked over the fields toward the sea, Thor cut off the head of one of the finest oxen, for bait. Of course you may know that Hymir was not pleased at this, but Thor said he should need the very best kind of bait, for he was hoping to catch the Midgard serpent, that dangerous monster who lived at the bottom of the ocean, coiled around the world, with his tail in his mouth.

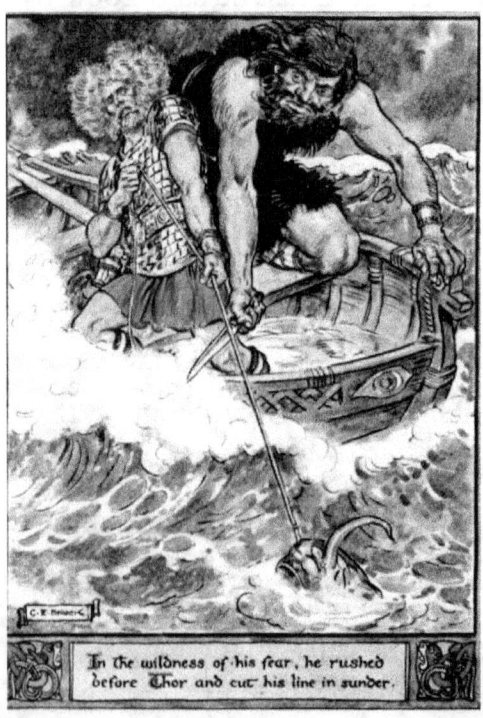

Thor & Hymir go fishing--Charles Brock--1930

When they came to the shore where the boat was ready, each one took an oar, and they rowed out to deep water. Hymir was tired first, and called to Thor to stop. "We are far enough out!" he cried "This is my usual fishing-place, where I find the best whales. If we go farther the sea will be rougher, and we may run into the Midgard serpent."

As this was just what Thor wanted, he rowed all the harder, and did not stop until they were far out on the ocean; then he baited his hook with the ox's head, and threw it overboard. Soon there came a fierce jerk on the line; it grew heavier and heavier, but Thor pulled with all his might. He tugged so hard that he broke through the bottom of the boat, and had to stand on the slippery rocks beneath.

All this time the jötunn was looking on, wondering what was the matter, but when he saw the horrid head of the Midgard serpent rising above the waves, he was so frightened that he cut the line; and Thor, after trying so hard to rid the world of that dangerous monster, saw him fall back again under the water; even Miölnir, the magic hammer, which Thor hurled at the creature, was too late to hit him. And so the two fishermen had to turn back, and wade to the shore, carrying the broken boat and oars with them.

The giant was proud to think he had been too quick for Thor, and after they reached the house he said to the thunder-god, "Since you think you are so strong, let us see you break this goblet; if you succeed, I will give you the big kettle."

This was just what Thor wanted; so he tightened his belt of strength, and threw the goblet with all his might against the wall; but instead of breaking the goblet he broke the wall.

A second time he tried, but did no better. Then the giant's wife whispered to Thor, "Throw it at his head!" And she sang in a low voice, as she turned her spinning-wheel,—

"Hard the pillar, hard the stone, Harder yet the jötunn's bone! Stones shall break and pillars fall, Hymir's forehead breaks them all!"

Yet again Thor threw the goblet, this time against the giant's head, and it fell, broken in pieces.

Then Tyr tried to lift the Mile-deep kettle, for he was in a hurry to leave this land of ice and snow; but he could not stir it from its place, and Thor had to help him, before they could get it out of the giant's house.

When Hymir saw the gods, whom he hated, carrying off his kettle, he called all his giant friends, and they started out in chase of the Æsir; but when Thor heard them coming he turned and saw their fierce, grinning faces glaring down at him from every rocky peak and iceberg.

Then the mighty Thunderer raised Miölnir, the hammer, above his head, and hurled it among the giants, who became stiff and cold, all turned into giant rocks, that still stand by the shore.

III.

Ægir was very glad to get Mile-deep; so he set to work to make the mead in it, to get ready for the great feast, at the time of the flax harvest, when all the Æsir were coming from Asgard to visit him.

Before the day came, all light and joy had gone from the sacred city, because the bright Baldur had been slain, and the homes of the gods were dark and lonely without him. So they were all glad to visit Ægir, to find cheer for their sadness.

There was Father Odin, with his golden helmet, and Queen Frigga, wearing her crown of stars, golden-haired Sif, Freyja, with Brisingamen, the wonderful necklace, and all the noble company of the Æsir, all except mighty Thor, who had gone far away to the giant-land.

As they all sat in Ægir's beautiful ocean hall, drinking the sweet mead, and talking together, Loki came in and stood before them; but, finding he was not welcome, and no seat saved for him, he began saying ugly things to make them all angry, and at last he grew angry himself, and slew Ægir's servant because they praised him. The Æsir drove him out from the hall, but once more he came in, and said such dreadful things that at last Frigga said, "Oh, if my son Baldur were only here, he would silence thy wicked tongue!"

Then Loki turned to Frigga, and told her that he himself was the very one who had slain Baldur. He had no sooner spoken than a heavy peal of thunder shook the hall, and angry Thor strode in, waving his magic hammer. Seeing this, the coward Loki turned and fled, and Asgard was rid of him forever.

The Twilight of the Gods

Loki and Fenrir, the wolf, were safely bound, each to his separate cliff, but still happiness and peace did not return to Asgard, for Baldur was no longer there, and light and joy had gone from the home of the gods. The Æsir felt that the Twilight of the gods, which Odin knew was to come, must be near.

Soon began a long cold winter; surely it must be the beginning of the Fimbulwinter, which was to come before the last great battle. From the north came cold blasts of freezing wind; snow and ice covered the earth; men could not see the face of the sun or the moon. Everywhere there was darkness; the people grew fierce and unhappy and wicked, for they seemed no longer to love each other. So the evil deeds of men kept on, and the fierce frost giants grew stronger and stronger. They killed the trees and flowers, and bound the lakes and rivers with icy bands.

Even when summer time came, the cold still held on, and no one could see the green grass or the beautiful golden sunlight. The frost giants were pleased to see the trouble they had brought upon men, and hoped they soon could destroy Asgard and the gods.

Three long winters passed, with no light to warm and brighten the world; after that still three other dreary winters, and then the eagle who sat on the top of the great world tree, Yggdrasil, gave a loud, shrill cry; at that the earth shook, the rocks crumbled and fell, so that Loki and the wolf were freed from their chains.

The waters of the deep ocean rose and rolled high over the land, and up above the waves writhing out of the deep, came the monster Midgard serpent to join in the last battle. Now the enemies of the gods were gathering from all sides,—the frost giants, the mountain giants, with Loki, Fenrir, and the Midgard serpent.

Heimdall on the Rainbow Bridge--Emil Doepler--1905

Heimdall, the faithful watchman, looked from his watch-tower by the rainbow bridge, and when he saw the host of monsters appearing and raging toward Asgard, he blew his magic horn, Giallar, which was the signal of warning to the gods.

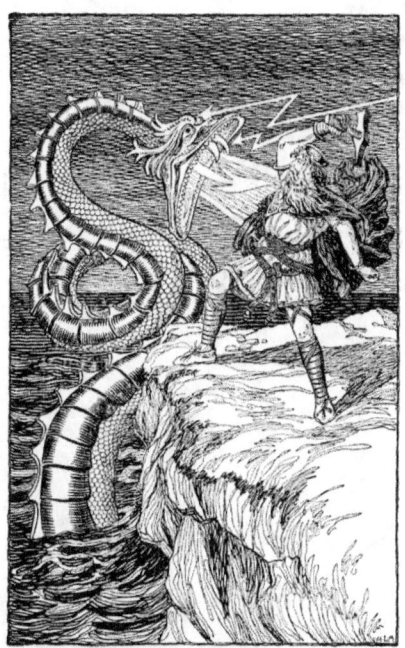

THOR FIGHTING THE SERPENT.

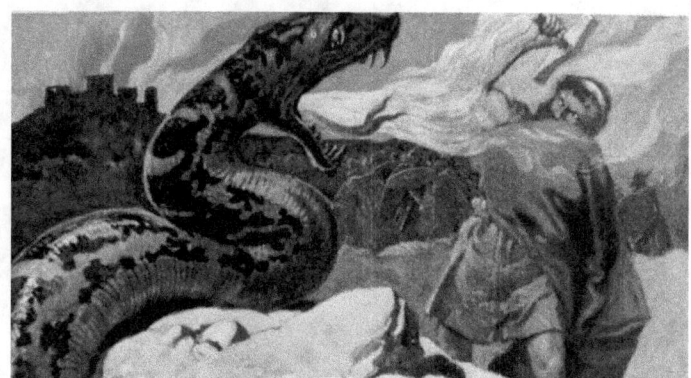

Thor and the Midgard Serpent--Emil Doepler--1905

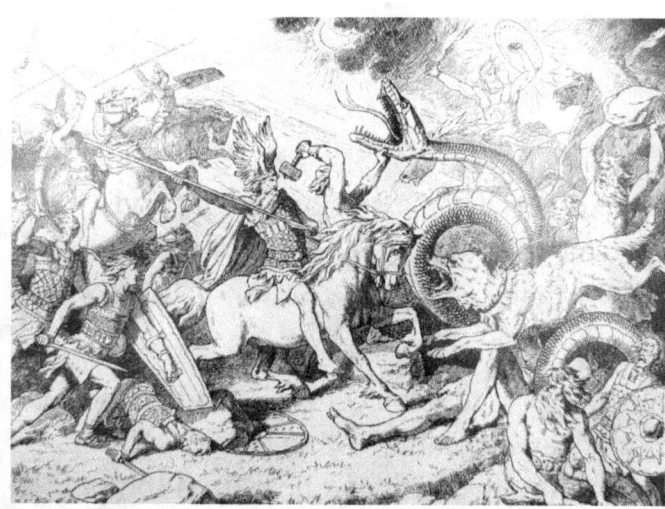

When Father Odin heard the blast of Heimdall's horn, he hastened to arm himself for the battle; once again it is said the Allfather sought wisdom at Mimir's fountain, asking to know how best

to lead the Æsir against their enemies. But what Mimir said to him no one ever knew, for a second call sounded from the Giallar horn, and the gods, with Odin at their head, rode forth from Asgard to meet their foes.

Thor took his place beside Odin, but they were soon parted in the struggle. The thunder-god fell upon his old enemy, the serpent, whom twice before he had tried to slay, and after a fierce fight, he at last conquered and slew the monster; but the poisonous breath from the serpent's mouth overcame the mighty Thor, and he also fell.

Odin and Fenris--Dorothy Hardy--1909

Heimdall and Loki came face to face, and each slew the other. Thus every one of the gods battled each with his foe, till at last the darkness grew deeper, and all, both gods and giants lay dead. Then fire burst forth, raging from Utgard to Asgard—and all the worlds were destroyed in that dreadful day of Ragnarök.

But this was not the end of all: after many months, and years, and even centuries had passed, a new world began to appear, with the fair ocean, and the beautiful land, with a bright, shining sun by day, and the moon and stars by night. Then once more the light and heat from the sun made the grass and trees grow, and the flowers bloom.

Baldur and Hodur came to this beautiful new world, and walked and talked together. Thor's sons were there, too, and with them, the hammer, Miölnir, no longer for use against giants, but for helping men build homes.

LIF AND FIFTHRASIR--LORENZ FRØLICH--1895

The new world that rises after Ragnarök, as described in *Völuspá* (depiction by Emil Doepler)

Two people, a woman and a man--Lif and Lifthrasir who were kept safe through the raging fire, now came to dwell on the earth, and all their children and grandchildren lived at peace with each other in this beautiful new world.

Baldur and Hodur talked often of the old days when the Æsir dwelt in Asgard, before Loki, the wicked one, brought darkness and trouble to them. With loving words they spoke of Odin and Frigga; and the brave Tyr, who gave his right hand to save the Æsir; of mighty Thor; and faithful Heimdall; of lovely Freyja, with her beautiful necklace; and of fair Iduna's garden,

where they used to sit and eat her magic apples. "But still," they said, "we know now that this new world is fairer than the old, and here, also, the loving Allfather watches over his children."

Wagner, Götterdämmerung

The title is a translation into German of the Old Norse phrase Ragnarök

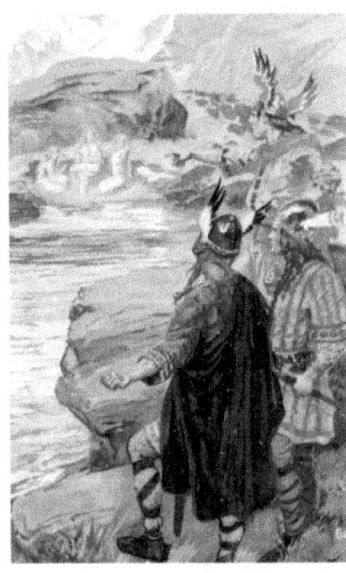

They saw on the margin of the lake, three maidens sitting and spinning flax

Götterdämmerung is a translation into German of the Old Norse phrase Ragnarök

Appendix

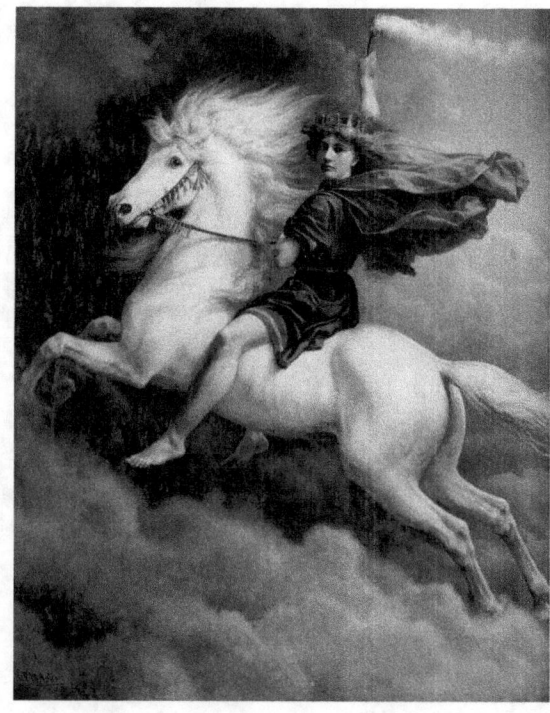

Dagr (Day)--Peter Nicolai Arbo--1874

Day following Night Lorenz Frølich

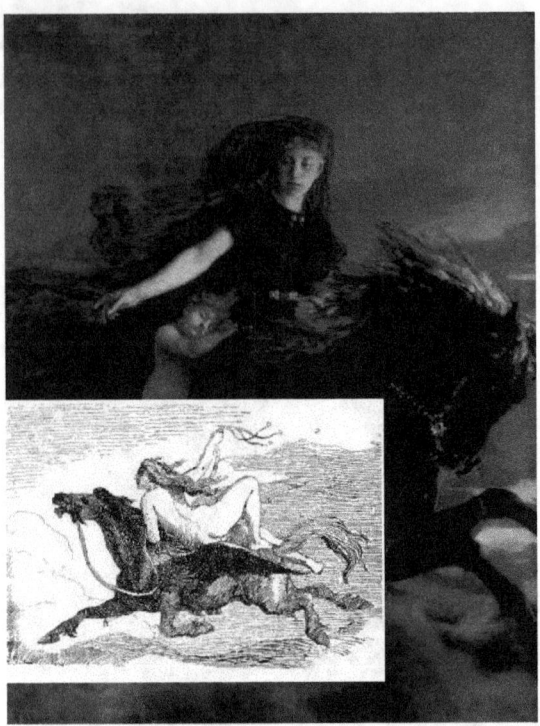

Nótt (night) rides her horse in this 19th-century painting by Peter Nicolai Arbo.

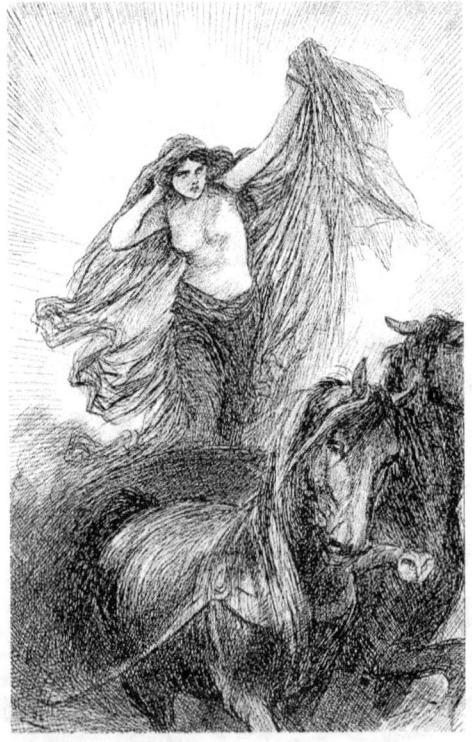

Night(Nótt)

Ostara (Ēostre): goddess of spring

Ostara (Ēostre) goddess of spring

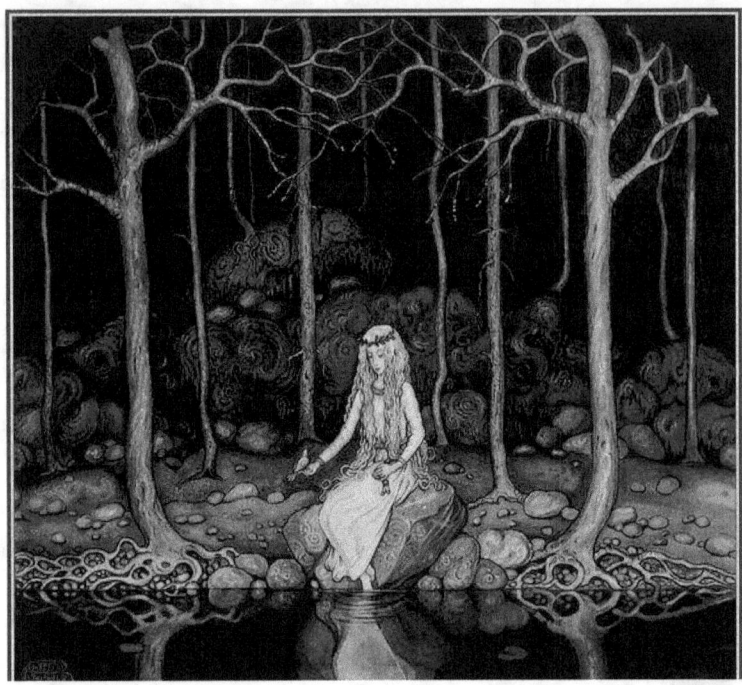

The Princess in the Forest--John Bauer (1882 – 1918),

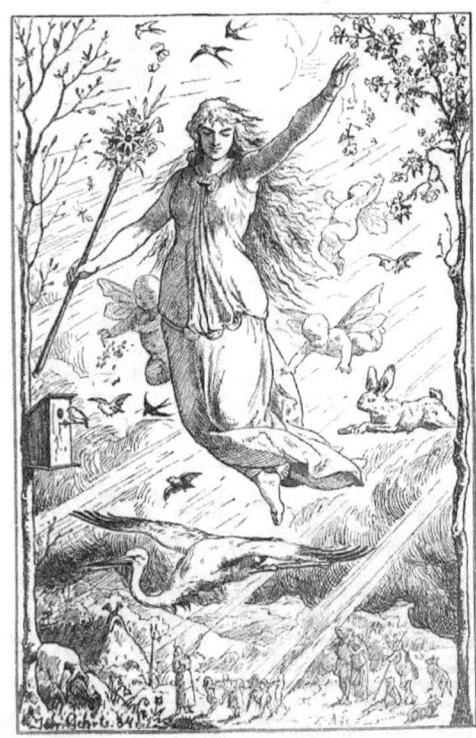

Ostara (Ēostre)--1884--by Johannes Gehrts.

Le premier dejeuner --Fritz Zuber-Buhler

Nu aux roses--Alice Kaub-Casalonga

The Spring Fairy--Jacques Clement Wagrez

In Norse mythology, Gefjon (Gefjun or Gefion) is a goddess associated with ploughing.

Gefjun Plows the Danish island of Zealand with her Oxen--1882-- Karl Ehrenberg

Gefion and King Gylphi--Lorenz Frølich--1906

Gefjun plowing with her four oxen – painting on the ceiling of Frederiksborg Palace, Denmark

A völvua (vǫlva vala, spákona, spækona) is a female shamanand seer.

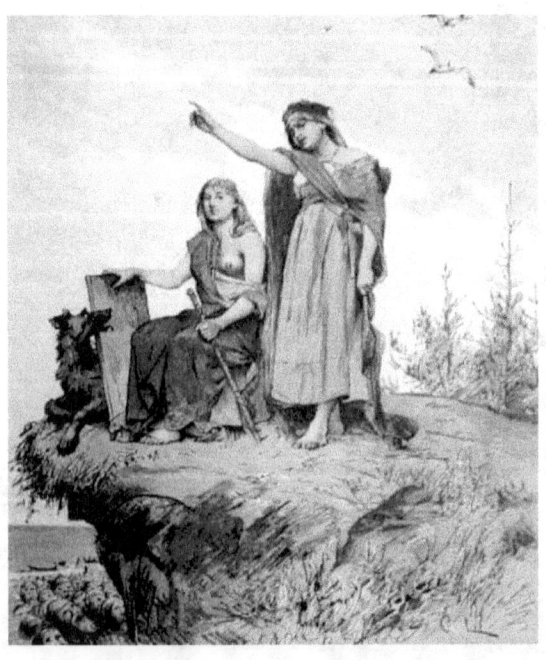

THE SEERESS SPEAKS HER PROPHECY IN THIS ILLUSTRATION TO A 19TH-CENTURY SWEDISH TRANSLATION OF THE POETIC EDDA.

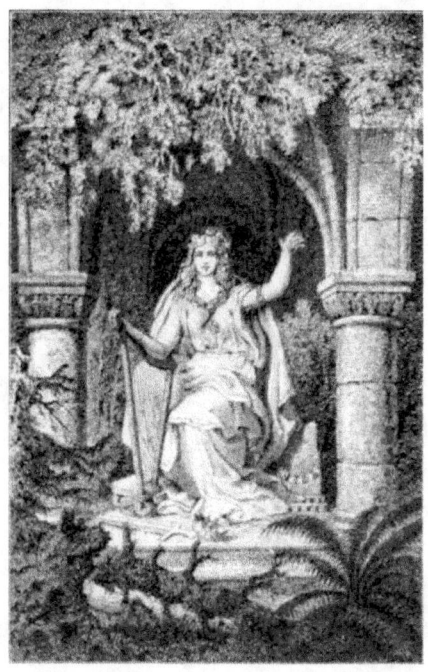

The Völva

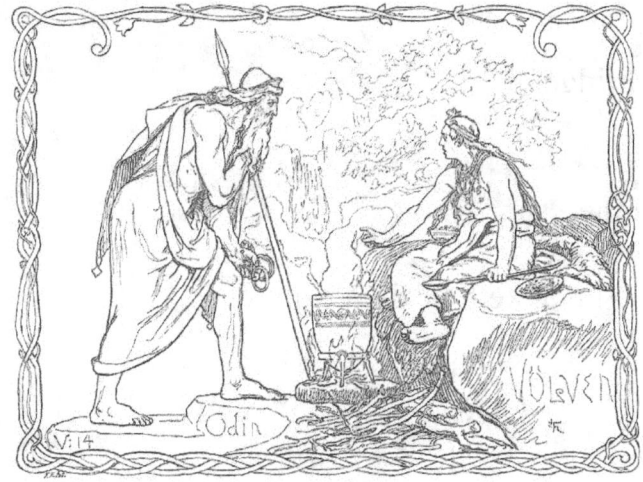

ODIN AND THE and völvua -- Lorenz Frølich--1895

INDEX OF NAMES.

- Ægir (ā′jir). God of the deep sea.
- Æsir (ā′sir). The twelve gods of Asgard.
- Alfheim (ălf′hīm). Home of the elves and of Frey.
- Asgard (as′gärd). The home of the Æsir.
- Baldur (bạl′der). The sun-god.
- Bifröst (bē′frẽst). The rainbow bridge.
- Bragi (brä′gē). The god of poetry. Husband of Iduna.
- Brisingamen (brĭ sing′ä men). Freyja's necklace.
- Brock. One of the elves.
- Fenrir. The monster wolf.
- Fimbulwinter (fĭm′bul). The last stormy winter.
- Frey (frī). The god of summer and of the elves.
- Freyja (frī′yă). The goddess of love and beauty.
- Frigga (frĭg′ä). The queen of the gods. Wife of Odin.
- Giallar-Horn (Gyäl′lar). Heimdall's trumpet.
- Gladsheim (glădz′hīm). Odin's palace.
- Heimdall (hīm′däl). Guardian of the rainbow bridge.
- Hela (hē′lä). Queen of the underworld.
- Hermod (hẽr′mod). The messenger-god.
- Hodur (ho′der). God of darkness. Baldur's brother.
- Hönir (hẽ′nir). God of mind or thought.
- Hymir (hē′mir). The frost giant who owned the great kettle called Mile-deep.
- Iduna (ē doon′ä). Goddess of spring.
- Jötunheim (yẽ′toon hīm). Home of the giants.
- Loki (lō′kē). God of fire.
- Midgard. The earth.
- Mimir (mē′mir). Guardian of the well of wisdom.
- Miölnir (myẽl′nir). Thor's magic hammer.
- Niflheim (nĭfl′hīm). The underground world.
- Niörd (nyẽrd). God of the seashore.
- Norns. The three Fates.
- Odin (ō′din). The father, or chief, of the gods.
- Odur (ō′dûr). Freyja's husband.
- *Poetic Edda*. The modern reference for an anonymous collection of Old Norse poems
- Ragnarök (råg′nå rûk). The Twilight of the gods.
- Sif. Wife of Thor.
- Sindri. One of the elves.
- Skadi (skä′dē). Thiassi's daughter.
- Sleipnir (slīp′nir). Odin's eight-footed steed.

- Thiassi (tē äs´sē). A frost giant. Skadi's father.
- Thor (thor or tor). God of thunder.
- Tyr (tēr) or Tiu (tū). God of war.
- Utgard (oot´gärd). City of the giants, in Jötunheim.
- Yggdrasil (ig´drå sil). The world tree.

VOCABULARY.

KEY TO PRONUNCIATION.

ā as in ale. ạ as in all. ẽ as in fern.

ă as in am. å as in ask. ī as in ice.

ä as in arm. ē as in eve. ĭ as in ill.

ō as in old. û as in urn.

oo as in foot. ū as in use.

www.ingramcontent.com/pod-product-compliance
Lightning Source LLC
Chambersburg PA
CBHW081153180526
45170CB00006B/2059